Cubism and its Legacy

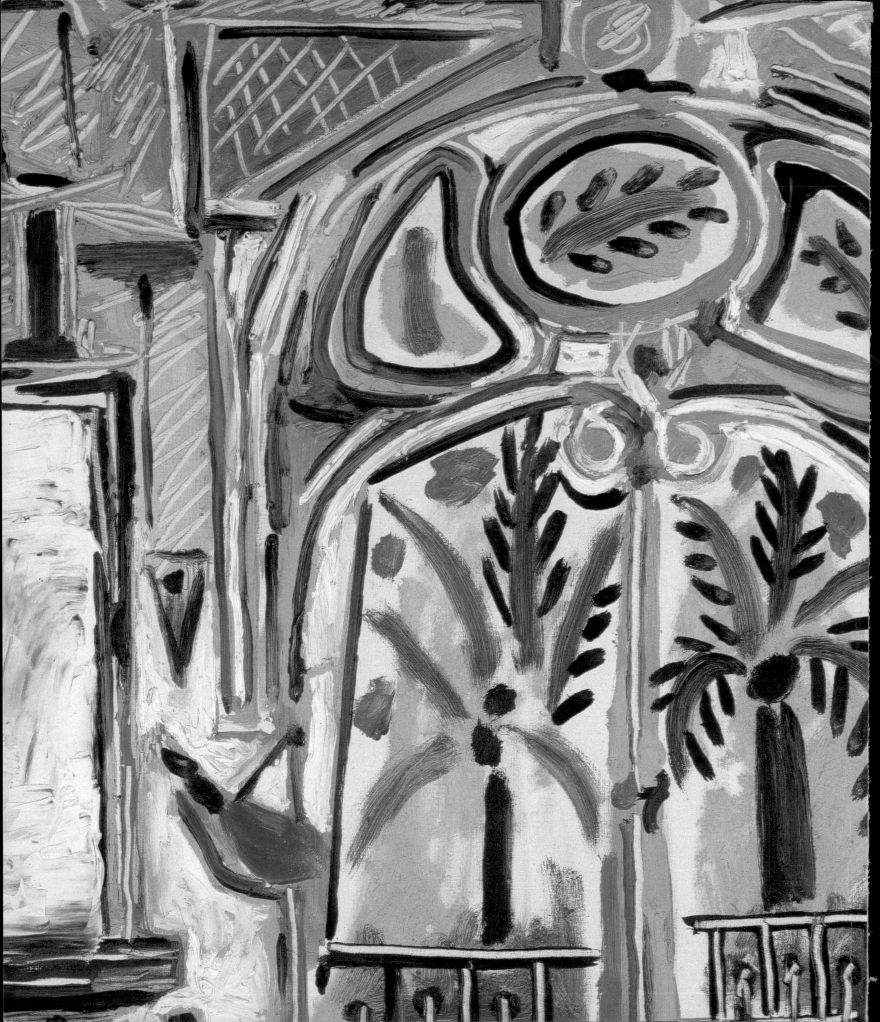

Cubism and its Legacy

The Gift of Gustav and Elly Kahnweiler

Edited by Jennifer Mundy
with contributions by Giorgia Bottinelli and Sean Rainbird

Tate Publishing

Published by order of the Tate Trustees on
the occasion of the exhibition at Tate Modern
24 May – 7 November 2004
and at Tate Liverpool
21 December 2004 – 2 May 2005

First published in 2004 by Tate Publishing,
a division of Tate Enterprises Ltd, Millbank,
London SW1P 4RG
www.tate.org.uk/publishing

British Library Cataloguing in Publication Data
A catalogue record for this book is available from
the British Library

ISBN 1 85437 541 5

Distributed in the United States and Canada by
Harry N. Abrams, Inc., New York

Library of Congress Cataloging in Publication Data
Library of Congress Control Number applied for

Catalogue design by
Peter B. Willberg and Nanni Goebel
at Clarendon Road Studio, London
Printed and bound in Great Britain by
Balding + Mansell, Norwich

Cover: Juan Gris, *Overlooking the Bay* 1921 (no.7)
Frontispiece: Pablo Picasso, *The Studio* 1955 (no.52, detail)
Page 24: Georges Braque, *The Billiard Table* 1945 (no.2, detail)

Measurements of artworks are given in
centimetres, height before width and depth

Abbreviations:
GB Giorgia Bottinelli
JM Jennifer Mundy
SR Sean Rainbird

b.c. bottom centre
b.l. bottom left
b.r. bottom right
t.l. top left
t.r. top right

Contents

Acknowledgements

Jennifer Mundy

I would like to express my gratitude to the following individuals and institutions for their help in research for this catalogue:

Julia Aries, Glyndebourne; Pierre Assouline; Anne Baldassari, Musée Picasso; Heinz Berggruen; Sir Alan Bowness; Cambridgeshire County Record Office; Fabio Carapezza Guttuso, Associazione Archivi Guttuso; Hartwig Fischer, Kunstmuseum Basel; Peter J.St.B. Green; Julia Hillgärtner; Beverley Hutchinson, the Army Personnel Centre; Peter Jellinek; Sigrid Kämpfer, Frankfurt Stadtarchiv; Julia Kelly, University of Manchester; Quentin Laurens, Galerie Louise Leiris; Daniel Marchesseau, Musée de la Vie Romantique; Guite Masson; James Mayor, The Mayor Gallery; Rosalind Moad, University of Cambridge; Günther Montfort, Bundesarchiv-Militärarchiv; Sir Francis Newman; Catherine Petch, The Henry Moore Foundation; Michael Phipps, The Henry Moore Foundation; Elizabeth Pridmore, University of Cambridge; Sir Norman and Lady Jean Reid; John Richardson; Ann Simpson, Scottish National Gallery of Modern Art; Margit Schröder, Städtische Kunsthalle Mannheim; Stephan von Wiese, Kunstmuseum Düsseldorf; John Wells, Cambridge University.

Particular thanks are extended to the staff of the Hyman Kreitman Research Centre, Tate, for their support. More generally, a debt is owed to Giorgia Bottinelli, Assistant Curator, Tate Collection, for her research for this volume as a whole.

Foreword

Nicholas Serota
Director, Tate

This exhibition celebrates the gift to Tate of the collection of Gustav and Elly Kahnweiler. In the 1950s and 1960s the Kahnweilers were among the few collectors in the United Kingdom with significant interest in continental avant-garde art. Thanks to their contacts and friendship with Directors Sir John Rothenstein and most especially Sir Norman Reid, they decided to leave their entire collection to what was then the Tate Gallery. In this their aim was to help Tate fill gaps in its holdings of international art and to express their gratitude to the country that had offered them asylum in the inter-war years.

A group of works was given to the Gallery by a Trust Deed signed in 1974 and in 1994 the remainder of the more important items entered Tate's collection after the death of Elly, who had outlived Gustav by a few years. With a sum of money accrued from the sale of other works and with the assistance of, in particular, the National Art Collections Fund, Tate was able to purchase in 2003 a major late work by the cubist master Georges Braque and thereby complete the Kahnweiler gift.

Sir Alan Bowness, Director of the Tate Gallery from 1980 to 1988 and co-executor of the Kahnweilers' wills, has written in this catalogue of his friendship with Gustav and Elly. I am most grateful to him for his personal memoir. Jennifer Mundy, Head of Research at Tate, has explored the fascinating story of Gustav Kahnweiler's origins in Germany, his early dealing, his relationship with his famous older brother Daniel-Henry Kahnweiler, and his life in Britain from the mid-1930s. I should like to thank her and Giorgia Bottinelli for their research into the lives of Gustav and Elly Kahnweiler, whose generosity towards Tate has so enriched the national collection of modern international art.

The English Kahnweiler

Alan Bowness

Kahnweiler – the name is familiar to anyone who knows a little about twentieth-century painting. Picasso's dealer, the young German who settled in Paris in 1907, and who in those heady years until the outbreak of the First World War in 1914 was almost alone in recognising every major development in modern art as it happened, buying Derain, Vlaminck, Braque, Picasso, Gris and Léger for his small shop in the rue Vignon where the revolutionary growth of cubism was nurtured. The gallery owner who then lost almost everything in 1914 because he was German, who took refuge in Switzerland, who had to change the gallery name (from Kahnweiler to Simon) as he rebuilt its fortunes between the wars, adding Masson, Klee and Laurens to his gallery artists. Once more he had to sell up and change the name (to Galerie Louise Leiris) because he was a Jew in Nazi-occupied France in the Second World War. Someone who became Picasso's main dealer in the post-war years and who controlled the gallery until his death at the age of ninety-four in 1979. A survivor with vision, obstinacy and tenacity on a grand scale.

This is not our Kahnweiler however. This exhibition celebrates his much younger brother, Gustav, born in 1895 and also an art dealer for a time but in a much more modest way. He was, as he often disparagingly called himself, 'le petit Kahnweiler'. I would prefer to remember him as the English Kahnweiler.

I first heard about Mr Kahnweiler from Henry Moore, his more or less exact contemporary, as an English collector who had lived in Cambridge and occasionally bought Moore's sculptures, large and small, both for himself and for his friends. Henry enjoyed his company and looked forward to his visits. I did not meet Mr Kahnweiler, however, until January 1980 when I became Director of the Tate. My predecessor, Sir Norman Reid, explained the rather complicated arrangement that the gallery had with this elderly and reclusive collector. For almost thirty years he had been leaving his more important paintings at the gallery, in store or on the walls as the Tate wished, whenever he left his home for one of his lengthy stays on the Continent. Norman had ensured that much of the collection – some thirty works – was already held in trust for the Tate, but the Kahnweilers had retained other desirable things.

When I finally met Gustav Kahnweiler I found a delightful, charming, almost avuncular small gentleman, dressed in English tweed and checked shirt, already in his eighties but lively and quick-witted and full of the enjoyment of life.

He invited my wife and me to visit him at Alderbourne Manor, a small country house near Gerrards Cross in Buckinghamshire that had been converted into several apartments.

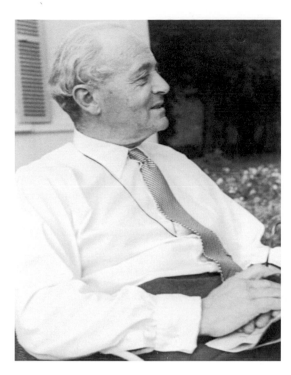

Fig.1
Gustav Kahnweiler
[Date unknown]
Tate Archive TGA 9223.3.23

and admired John Christie, and for this reason asked that the Tate should lend his Henry Moore *Draped Reclining Woman* 1957–8 (no.45) to Glyndebourne, with the significant proviso that it was to be withdrawn should their musical standards decline. (Those who see it now during the summer festival with champagne glasses on the base of the sculpture might think it is not so much the musical standards as the social behaviour that should have been the subject of Gustav's proviso.)

Gustav was very Anglophile, deeply grateful for this country's hospitality. He admired the manners of the English gentleman and liked to be taken as one. But of course he had a personal breadth of culture, which, lightly as he wore it, was typical of his affluent and cosmopolitan German background rather than of his adopted country. He spoke and read four languages, and had a deep love of English, German and French literature. I got on well with him partly because I spoke German and knew the classics. He had a good small library – few recent books but a complete set of Conrad novels, for example. He liked the Polish-born Conrad for the fluency of his command of English, which he shared. He had art and architecture and travel books dating back to younger days in Germany, including a complete set of Zervos's Picasso catalogue.

I often tried to get Gustav to talk about his past, not with great success. It was left behind, and only occasionally recalled. He obviously came from a very wealthy German merchant family, orginally Jewish but long since completely assimilated. Gustav seemed to have no religious beliefs. As a young man in the First World War he told me he had been a junior officer in a German

The Kahnweilers lived on the first floor in modest style, in beautiful rooms, chosen for the view across the splendid grounds to the lake, before which was sited one of Henry Moore's magisterial reclining women.

We were introduced to Gustav's wife, Elly – tall and elegant and still beautiful in her eighties. She had clearly been a very handsome woman, and was proud of her appearance. We were invited to the first of many Sunday lunches, latterly often at the Waterside Inn at Bray, one of the finest restaurants in England, where Gustav was a friend of the patron, Michel Roux.

Gustav was totally devoted to Elly whom he had married in 1925, and sought to have the best for her. Their continental peregrinations were always from one grand hotel to another, with several weeks in each place – Paris, Switzerland, Venice, Rome. In the 1980s there was a winter tour, centred on Switzerland, and a shorter summer one, normally to Venice. Once in residence, they would entertain friends to dinner, locals and visitors alike. When at home in England, in Cambridge and from 1956 at Alderbourne, they did not go out very much. Once a week the chauffeur would drive them to London when Elly went to the hairdresser and Gustav visited the Tate and the National Gallery. Visits to Glyndebourne every summer were a regular treat: Gustav knew

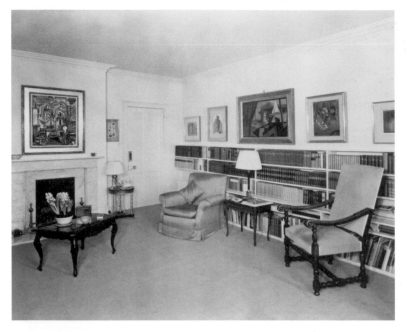

Fig.2
**View of the sitting room,
Alderbourne Manor, Gerrards Cross**

Works on walls from left to right:
Picasso, *The Studio* 1955; Miró,
Dancer 1935; Braque, *Still Life* 1924;
Laurens, *Bottle and Glass* 1917;
Gris, *Overlooking the Bay* 1921;
Gris, *Bottle of Rum and Newspaper*
1913–14; Klee, *Historical Site* 1927
Tate Archive TGA 9223.3.36

cavalry regiment, and this would I think mean that he was registered nominally as a Christian. Elly was certainly Christian, and perhaps Gustav's devotion to her (they had no children) was in part because his Jewish origins had brought calamity and disruption into their lives – he felt he could never quite compensate her for this. The reconciliation of Christians and Jews was a cause close to their hearts.

Gustav had enjoyed his early career as an art dealer in Germany, albeit as an adjunct to his powerful and domineering elder brother, Daniel-Henry, whose German associate, Alfred Flechtheim, had in 1921 offered Gustav a junior partnership. Flechtheim had quickly become one of the most active dealers in modern art in Germany, and in the mid-1920s he had galleries in Berlin, Cologne, Düsseldorf and Frankfurt. Gustav worked in the last two; he was also a partner in the syndicate that bought many works by Braque, Gris, Léger, Derain and others in the sale of sequestrated Galerie Kahnweiler paintings in 1921–2.

I never had the impression that Gustav was a dedicated art dealer like his brother. It was just that it was a better life than the family professions of banking, stockbroking, or gold and diamond trading. By the later 1920s, at the time of deep economic problems in Germany, I think he had lost interest. There were some compensations. He had got to know artists and enjoyed

their company – Juan Gris in particular and Paul Klee. He always spoke with deep regret of Gris's early death in 1927 at the age of forty. In so far as he would ever talk about art (and this was rare), I remember best his conviction that the late paintings of his friend Juan Gris were not a decline.

The rise of Hitler put an end to Gustav's art dealing. He was quick to see the need to leave Germany and make a life in another country, as his brother had done many years before. Gustav and Elly came to England in the winter of 1935–6, and settled in Cambridge where Gustav's nephew Peter was studying, though relations with his sister's family were never close. I am sure Gustav could have made a career in Bond Street as so many of his fellow refugees did with great success. But he preferred to live quietly in Cambridge, and even this life was interrupted in 1939 by the war and subsequent internment and then service in the British army. Gustav occasionally compared the Pioneer Corps with the German cavalry, with a certain wry amusement.

What exactly Gustav did in the years after the war, apart from a little private dealing, was never clear to me. He remained closely in touch with his brother's gallery in Paris, and probably played a greater role than we realise, especially after Daniel-Henry's death in 1979. He particularly liked Daniel-Henry's stepdaughter, Louise Leiris (as did everyone who met her), and her husband, the poet and writer Michel Leiris. There

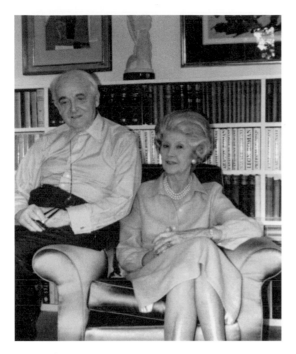

were frequent visits to Paris, and I remember
Gustav talking of regular weekly phone conversa-
tions with the omni-competent gallery manager,
Maurice Jardot.

Gustav's own finances were always mysterious
to me. He appeared to have no money or serious
investments in the UK, but family funds in
Switzerland supplied whatever money he needed.
As he and Elly lived well, these must have been
considerable. As one of the executors for Gustav
and Elly – a task that fell to the Director of the
Tate but which I retained after my retirement in
1988 – I was surprised to find how few papers
Gustav had kept. He was never a letter writer
himself, preferring to telephone, and he did not
retain any correspondence received. He asked a
friend to destroy his diaries and notebooks after
his death.

There was always something a little curious
about the Kahnweilers, as though they could
never feel entirely confident that their good
fortune would continue. Sometimes one thought
that there was a suitcase in the hall, and that they
could leave the country at short notice. They had
never owned a house, and had no family and
few close friends who would miss them. All they
would leave behind were the paintings and
drawings, and these were promised to the Tate.

And although there are half a dozen important
works, it was always an unostentatious collection,

suitable for a small domestic interior, never made
with an eye to its eventual place in a museum.
Thinking of the opportunities he had had, I did
tentatively ask Gustav if he regretted this, but
such a final destination had not ever occurred
to him when he first acquired the works.

Like many collections their acquisition was
not planned. The cubist works – only two before
1920 – can be associated with Gustav's gallery
activities in 1920–7 and his brother's taste: the
twelve splendid Gris; three small Légers; a Braque
drawing; two small Laurens sculptures together
with a collage and a gouache; the four Klees.
The Marie Laurencin was Elly's picture and hung
in her bedroom at Alderbourne. Nothing impor-
tant was added in the 1930s and 1940s. After
1950 came Gustav's more personal choices: the
Picassos (nine great prints, a painting and a
drawing), the Moores, definitely not to his
brother's liking – four maquettes, a drawing and
the *Draped Reclining Woman* (no.45) (perhaps like
Picasso's *The Studio* (no.52) this was acquired
with the Tate in mind); and works by his friends
André Masson and Renato Guttuso.

Gustav was aware that much of what he owned
was not suited for a big public museum. He told
Elly, long before he died in 1989, that all the
lesser works should be sold so that one major
work by an artist he admired could be bought for
the Tate in their name. When we came to sort
out the works that were in Elly's possession at the
time of her death in 1991 – over a hundred of
them – it seemed sensible to select only some
twenty-seven, which would strengthen the collec-
tion and make it worthy of one of the greatest
benefactors the Tate has ever had.

A Gesture of Appreciation

Jennifer Mundy

'Elly and I ... were very proud that we both could show to you and your board how sincerely we felt that in signing the foundation document, we have the interest of the Tate Gallery in our mind, and we both hope that in doing so we tried to show our gratitude and loyalty to our adopted country.'[1] These words to Sir Norman Reid, Director of the Tate Gallery, were written in January 1974 in thanks for a luncheon to mark the promised gift of a significant group of works from the collection of Gustav and Elly Kahnweiler. They express in simple and personal terms the Kahnweilers' view of this benefaction, a view echoed in the Trust Deed, signed a few weeks later, in which the gift was described as 'a gesture of appreciation' by the Kahnweilers 'to the people of Great Britain for the asylum granted to them following the rise of Hitler to power'.[2]

Gustav Kahnweiler was a self-effacing man, who rarely spoke about his beliefs or his past. Friends remember him as cultured and charming but few can recall conversations that revealed much about his past or his views on the art works he owned.[3] Gustav neither boasted of the good fortune that had brought him into contact with some of the great figures of twentieth-century art nor bemoaned the difficulties he had faced as a Jew in Hitler's Germany and, from 1935–6, a German in England. He and his wife became utterly Anglophile, loving what they saw as the innate decency of the British and, as the extremely rare personal statement made in the letter and Trust Deed revealed, it was this sentiment that lay behind their decision to leave their collection to the Tate Gallery.

Relatively few details are known today about the circumstances in which Gustav formed his collection. A number of the archives in which this information might have been found were either destroyed in the Second World War or are currently not available to researchers.[4] Kahnweiler left no personal papers and had his dairies destroyed after his death.[5] Although he was interviewed by writers investigating the lives of his celebrated older brother, the Paris-based dealer Daniel-Henry Kahnweiler, and the dealer Alfred Flechtheim with whom Gustav worked as a partner in Germany in the 1920s,[6] Gustav is not known to have recorded anywhere his recollections about his life or thoughts about art. Independently wealthy, he and his elegant wife Elly (born Elisabeth Conrad, 1901) lived an extremely comfortable life in England, first in Cambridge and, from 1956, near Gerrards Cross in Buckinghamshire, seeing their circle of friends and travelling in Europe for five or six months a year.

Although Gustav and Elly Kahnweiler chose not to publicise or draw attention to their collection in any way, it was distinctive and, for many years, it was one of only three significant collections of international art in Britain.[7] Built up largely in two stages – in the 1920s when Gustav acted as a dealer in Germany, and in the post-

Fig.4
Gustav Kahnweiler
[Date unknown]
Tate Archive TGA 9223.3.44

Second World War years when it was extended significantly – it was very much a Kahnweiler collection, mirroring by and large the tastes and commercial activities of his older brother. As proprietor of the Galerie Kahnweiler in the years before the First World War, the Galerie Simon in the inter-war years, and finally as director of the Galerie Louise Leiris after the Second World War, as well as author of texts on many of the artists represented by his galleries, Daniel-Henry Kahnweiler was a respected, indeed famous, figure in the Paris art scene. Most of the artists in Gustav's collection were represented by his brother's galleries, and the majority of the works came to him via his brother; to this extent, Gustav was, as he said self-deprecatingly, 'le petit Kahnweiler'.[8] However, the collection that Gustav established in Britain and for many years lent to the Tate Gallery had few rivals on this side of the Channel. For complex reasons, cubism, and the art that in the inter-war period was championed by Daniel-Henry as its legacy or development, was hardly bought by British collectors; and debates in the popular press of the 1920s and early 1930s would suggest that even two decades after it had originated, cubism was not widely understood, let alone appreciated. The story of Gustav and Elly Kahnweiler's collection is thus intertwined with the story of the mixed reception in Britain of

modern international art. This – as successive Directors of the Tate Gallery were aware – made the gift of the collection to the nation all the more valuable.[9]

Gustav Kahnweiler was born in 1895 in Stuttgart, the youngest of three children (Daniel-Henry was born in 1884, and a sister named Auguste was born in 1890). The family was very prosperous, and had a staff of housemaids, cook, chauffeur and French-speaking governesses. Although Jewish, the family was not practising: neither son ever felt particularly Jewish.[10] The father was a businessman and broker, who worked in large part for his London-based brothers-in-law, Sigmund and Ludwig Neumann, bankers and speculators, who controlled gold and diamond mines in South Africa. Daniel-Henry displayed academic ability and had a precocious love of art and music, but there was no question of his being allowed to go to university. Instead, his family secured for him a junior post in a bank in Frankfurt at the age of seventeen. Uninterested in his father's world of finance, he tolerated this career path while pursuing his passions for art and music for six years before launching himself, with financial assistance from his uncles, as an art dealer in Paris in 1907.

Gustav, too, was destined by his family to be a banker but, like his older brother, he had no desire to follow this path. War intervened, and while Daniel-Henry, his wife and her daughter by a previous relationship, secured asylum in Switzerland, Gustav joined a cavalry regiment and fought in the war. According to Pierre Assouline who interviewed Gustav Kahnweiler while researching a biography of Daniel-Henry,

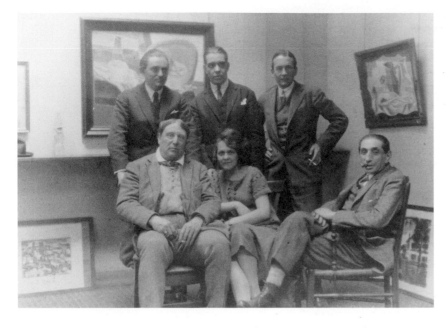

Gustav was 'permanently marked' by this experience.[11] At some point in the post-war years the family agreed to support Gustav's ambitions to follow in his brother's footsteps and offered a lump sum with which to set up a dealership.

Published excerpts of Daniel-Henry's correspondence with Alfred Flechtheim, a German art dealer and friend based then in Düsseldorf, throw light on Gustav's position in the early 1920s. Having learnt that Flechtheim wanted to open a branch of his gallery in Berlin, Daniel-Henry wrote on 13 December 1920, 'My brother would really like to become involved in art dealing in the future … He is still with Forchheimer [his brother-in-law].[12] But in the future – qui sait?: what would you think of his joining you with a view to an eventual partnership?'[13] Flechtheim liked the idea, and talked of opening a Berlin branch the following April. On 18 February 1921 Daniel-Henry referred to a 'sizeable sum' that his brother had invested in Flechtheim's gallery, and said that Flechtheim should not allow the Berlin gallery to focus simply on French art, nor even on French art and Rhineland art, as this might be seen as promoting separate 'tendencies'. Instead, he advised him to focus on 'good new German artists': 'Not those who are already known, the Expressionists, but those that are up and coming … Don't rush things. It won't bring you a lot, but then you don't need to pay young men very much'. He added, 'Naturally, I could also get you Matisse. My brother also speaks about you

becoming Klee's representative eventually in Berlin. That would not be bad.'[14] Gustav signed a formal contract with Flechtheim in April 1921. Its terms are not known, but in a letter written on 25 February Flechtheim revealed to Daniel-Henry that they had discussed Gustav having one quarter or one third of the business in Düsseldorf and half that of the Frankfurt gallery.[15] The Berlin gallery opened in October. Gustav took temporary charge of the Düsseldorf branch in January 1922 before becoming director of a new branch in Frankfurt in November 1922. It is not known how long the latter gallery survived but for a period – certainly between 1925 and late 1927[16] – it was called Galerie Flechtheim und Kahnweiler.

In these years Gustav was an active, albeit junior, partner in the affairs of Flechtheim and, by extension, of his brother. When interviewed about Flechtheim towards the end of his life, Gustav stressed the latter's dependency on his brother's gallery, the Galerie Simon (named after the business's financial backer). Contacts with French artists, he said, 'went almost exclusively through my brother and as far as I know Flechtheim bought the work of no French artists, or virtually none, who were not represented at the Galerie Kahnweiler [sic] in Paris. And after I became a partner, I intensified this personal exchange, this selling of French art from the Galerie Kahnweiler'.[17] He commented that Flechtheim had some German artists under contract: not established figures such as Max

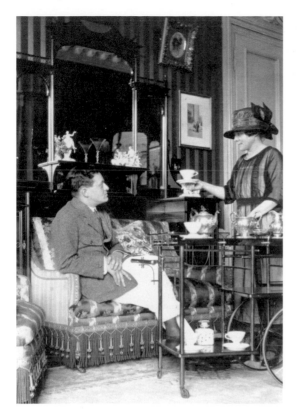

*my brother, had no real interest in making money
and becoming rich. [. . .] He was so striking, and had
an outrageous wit, irony, and an outrageous sense
of fantasy – you could also call it lying – but never to
make money, only to tell interesting stories.*[19]

In 1921–2 Gustav was involved – financially at
least – in a syndicate set up by his brother to
reclaim some of his gallery's stock that had been
sequestrated by the French government as enemy
property at the beginning of the First World War.
Along with other German-owned collections,
Daniel-Henry's stock was auctioned off in four
sales in 1921–2, the proceeds going to the French
state as reparation for Germany's war debts.
Daniel-Henry did all he could to prevent the dis-
persal of his stock, arguing vehemently that the
flooding of the market with cubist works would
not only ruin him but also have disastrous conse-
quences for the artists concerned. He begged the
artists Braque, Derain, Léger and Vlaminck – all
French war-veterans – to make representations on
his behalf to the French government: 'I have not
been just an ordinary dealer ... do this for me.
I am counting on the four of you ... If the four of
you petition for the return of my stock, so that
I can be permitted to resume my business, they
will do it ... I can't tell you how distasteful I find
all this. It's so ugly. To have worked so hard in
good faith, for a worthy cause, and still have to
fight every day for one's wretched possessions.'[20]
The artists did write but to no avail. Daniel-Henry
brought together his closest friends and associ-
ates – his brother, Louise Godon (his wife's
daughter, later known by her married name
Louise Leiris), his brother-in-law Hans
Forchheimer, Flechtheim and Hermann Rupf,
a close friend and great collector of cubism –

Liebermann but lesser, now almost forgotten
figures such as Nauen, Heuser, de Fiori and Haller.
However, Flechtheim never sought to export the
work of these artists abroad. Instead he focused
on promoting French art – nearly all of which he
obtained from the Galerie Simon – within
Germany. He freely acknowledged his personal
debt to Daniel-Henry: reviewing his career to date
he said in an interview of 1927, 'for me the most
inspiring contact was with Kahnweiler, to whom
I owe what I am now'.[18]

He could be maddening but Flechtheim was a
larger than life character who inspired affection.
Gustav later said of him:

*Flechtheim was a remarkable person. Physically he
was abysmally ugly and was very proud of it. He had
a very interesting head, which inspired many artists
to make sculptures or paintings of him. He was
someone that, once seen, you would never forget,
someone who had a great 'sense of humour', but not
much interest in earning money. For him the main
thing was love of art and love of artists and friends;
in fact, he was not really a businessman. Flechtheim
was very much loved in Berlin art circles, and things
were going well in business, though, as I said he, like*

to form a syndicate to bid for works in the sales under the pseudonym Grassat. Although hampered by a lack of funds, the syndicate (or, rather, Daniel-Henry Kahnweiler himself) seems to have had two main aims: to buy not so much the very best works but rather a reasonable stock that would allow him to function as a dealer once more; and, beyond this, to support the work of artists whose prices might otherwise have fallen through the floor and threaten the artists' chances of making a decent living in the years to come. In the first of the four sales the syndicate bought ten Braques, three Derains, nine Gris, and two Vlamincks for under 25,000 francs. In the second, when prices were lower, the syndicate secured four Braques, six Derains, three Vlamincks, seven Gris (between 100 and 200 francs a piece), one Braque papier collé, and watercolours by Derain, Vlaminck, Gris and Manolo. However, the net result of the sales was that while the prices of more commercial artists such as Derain held up relatively well, the prices of Braque dropped by more than two thirds and those of Gris and Léger by around ninety per cent.[21]

While Daniel-Henry slowly rebuilt his business, attempting with mixed success to retain the loyalty of the artists he had had under contract before the war, Gustav began to establish himself in Germany in the mid-1920s as a dealer in his own right. Early purchases may have included two rather staid prints by Vlaminck, an artist whose works Gustav described as selling like hot

cakes in Germany.[22] More certain is his purchase of works by Gris, beginning with a suite of prints in 1921 and followed the next year by his only purchase of a pre-war cubist work, *Bottle of Rum and Newspaper* 1913–14 (no.6), and a major oil, *Overlooking the Bay* 1921 (no.7). In 1924 he acquired at least three gouaches and an oil entitled *Pierrot with Book* (nos.14–17). Sir Alan Bowness, Director of the Tate Gallery from 1980 to 1988, has recalled that Gustav spoke with affection about Gris.[23] The artist lived next to Daniel-Henry in Boulogne-sur-Seine on the outskirts of Paris, and dropped by nearly every day. He also regularly attended the informal and lively Sunday gatherings of artists and writers hosted by Kahnweiler and his wife Lucie. It therefore seems likely that Gustav met Gris on a visit to his brother's home. Gustav may not have been as close to Gris as his brother but nonetheless, in 1927, the year of his death, Gris inscribed a drawing, 'To Monsieur Gustave Kahnweiler / With kindest regards [en toute sympathie'] / Juan Gris 1927' (no.13).

Gustav also bought in this period works by André Masson, who had joined the Galerie Simon in 1922. Although Daniel-Henry was later critical of such surrealist artists as Miró, Magritte and Dalí, he was friendly in these years with a number of young writers associated with the surrealist movement, notably Michel Leiris and Antonin Artaud. Masson subsequently became a key figure in the surrealist movement, but Daniel-Henry discovered him in the early 1920s at a time when he

Fig.9
Elie Lascaux
In the Forest of Chaville 1931
Dans la forêt de Chaville
Watercolour, gouache,
crayon and pencil on paper
48.5 × 66.4

appeared to be taking cubism in a new direction. Gustav bought *Pedestal Table in the Studio*, 1922 (no.34), in the year it was painted, and eventually owned no less than ten works of the 1920s, including a number of automatic drawings made at the height of Masson's involvement with the surrealist group. Gustav was friendly with Masson after the war – the artist dedicated a lithograph to Gustav and Elly for their silver wedding anniversary in 1950 [24] – and it seems likely that Gustav's acquisitions of works of the 1920s reflected personal contact, and even friendship, with Masson in this earlier period.

Friendship and familial ties counted a great deal for Daniel-Henry and, it would seem, for Gustav too. Daniel-Henry conceived his role of dealer as a vocation rather than a profession. Profit was necessary but was not the goal of his business activities. Unlike many other dealers, he began by choosing to work with young unknown artists. Trusting his own judgement, he was willing to invest time and money in them in the hope that, given financial support, they would flourish and their works become increasingly valuable. In return, he demanded, where he could, an exclusive contract. This meant that an artists' entire production for the period of the contract came to him automatically at previously agreed rates. In this way he built up, for example, extraordinarily comprehensive holdings of the works of Picasso and Braque in the years in which they pioneered cubism.

With his choice of Masson and the sculptor Laurens, Daniel-Henry's flair for picking important artists of the future showed itself in the inter-war years. However, his tastes in modern art remained based on – and increasingly circumscribed by – precepts that derived from his understanding of the essence of cubism. He condemned abstract art as a worthless aberration: some commentators saw it as a development of cubism but he viewed it as merely a form of decoration, lacking the vital connection with reality that cubism (and, he argued, all great art) had always retained. In the inter-war and post-war years he took on, and steadfastly promoted alongside the 'greats' with which his name would always be associated, minor artists whose work reflected cubism, such as André Beaudin, Suzanne Roger, José de Togores and Eugène de Kermadec. He first met Suzanne Roger and André Beaudin in the company of Gris, and subsequently emphasised what he saw as their debt to the cubist master. Beaudin, he said, 'subjected the excesses of passion to a lucid reason to a desire for order, clarity, purity',[25] while he described Roger's 'disassociation of drawing from colour' as one of the great lessons of cubism.[26] Stretching a point, Daniel-Henry even evoked the legacy of cubism in defending Elie Lascaux – his brother-in-law – against the charge of being a Sunday painter: 'In his tender and poetic pictures the lesson of Juan Gris is apparent in the continuity which pervades and unites every part of the canvas'.[27]

The collection of Gustav and Elly Kahnweiler contained many works by such lesser known artists, which they may have acquired partly as tokens of friendship and of loyalty to the family's artists (figs.8–11).

The rise to power of Hitler in Germany in early 1933 dramatically changed the lives of Gustav and Elly. The Flechtheim galleries had survived the hyperinflation of the Weimar Republic and the onset of the Depression, but the rhetoric of the National Socialist party – both anti-modern art and anti-Jewish – as well as the boycott of Jewish-run businesses led Flechtheim to shut his galleries and leave Germany. Daniel-Henry withdrew his stock from Flechtheim's galleries in September and Flechtheim closed them in November 1933. According to a friend, Gustav and Elly sat up one night discussing their situation following some incidents of anti-semitic violence, and decided the next morning to load what they could into the car and drive over the border (their driver returned to collect more of their things on subsequent occasions).[28] They seem to have headed straight to Paris, where Flechtheim also went. Daniel-Henry Kahnweiler wrote in late November to his friend Rupf, 'Gustav is still here and is thinking of travelling to London soon to see if he can do something with paintings in a place where commerce reigns supreme. Let's keep this to ourselves. Flechtheim, too, is thinking about this (also between you and me). Whether London, which is so terribly close to Paris, really offers a chance, heaven alone knows.'[29] Flechtheim came to London in early 1934, but the Kahnweilers were in no hurry and arrived only in the winter of 1935–6.[30] They settled in Cambridge, a choice

that may have been determined by the proximity of family relatives: his nephew studied at the university from 1934 to 1937 and may have been accompanied by his mother, Gustav's sister Auguste, while his aunt by marriage was then living in Newmarket.[31]

If Gustav Kahnweiler had entertained hopes of being active in the British art scene, the limited market for continental avant-garde art in Britain may have forced him to review his plans. He later said that even Flechtheim, whose flamboyance was rather admired in British art circles, failed to make any money in these years.[32] Press reviews of the period would suggest that many critics of the popular press viewed continental modern art with deep suspicion. Many shrank from what they perceived as its anti-humanist and overly intellectual qualities. Reviewing the highlights of a future bequest of modern works to the Tate Gallery, the Director J.B. Manson praised a Braque still life of 1928 – a highly legible work representing a guitar and jug – for the qualities of its 'design' but concluded: 'It is an interesting experiment; it may be too intellectual to be a genuine work of art; it is doubtful whether it can communicate emotion without involving, in the process, too many intellectual experiences.'[33] Although these words were written in 1929 by a figure well known for his conservative tastes, such dislike of intellectualism was a recurrent theme in British commentaries on late cubist and abstract art in the inter-war years and hindered deeper appreciation of the achievements of these movements. Widespread ignorance about modern art in England provoked a defender of modernism, Geoffrey Grigson, to complain in his book *The Arts Today* (1935):

Fig.10
André Beaudin
Trees 1959
Les Arbres
Oil on canvas
46 × 38

*One thing we in England should now be able
to accept without pain or surprise – the series
Cézanne – Cubism – 'Abstraction'. Cézanne died in
1906; he was born two years after the accession
of Queen Victoria. Picasso was born in 1881,
Cubism in 1908. These names with what they
signify should be as firmly stuck in our pavements
as lamp-posts, as Lord Tennyson, as August 4th,
1914. We should be able to guide ourselves by
them, and catch hold of them when the traffic
of nonsense or reaction becomes too thick and
dangerous. But a majority of us, so it seems,
can do no such thing.*[34]

Gustav seems to have led a semi-retired life
in Cambridge in the 1930s and had only limited
contact with the art world. He saw his former
partner Flechtheim only once or twice in London
before the latter's untimely death in 1937.[35]
Through Flechtheim, however, he came into
contact with Freddie Mayor of the Mayor Gallery,
who was already a business associate of Daniel-
Henry (nearly all the continental works shown
at the Mayor Gallery in the 1930s came from
Daniel-Henry, Flechtheim or the latter's former
associate Alex Vömel of Düsseldorf).[36] Gustav 's
name first appears in the records of the Mayor
Gallery in late 1936 when he lent a group of
works by Gris, including *Overlooking the Bay* and
Pierrot with Book (nos.7 and 17) to a Gris exhibition.
The seven works in question are marked in
the register as having come directly from

Switzerland, suggesting that Gustav may have
had them stored there following his departure
from Germany. The Mayor Gallery records also
indicate that in the late 1930s he owned, or
handled, a number of works by Rouault, Signac,
Laurencin, Gris and Picasso that were not
included in the eventual gift to the Tate Gallery.

By September 1939 there were approximately
75,000 refugees of German nationality living in
Britain. Though the vast majority of these had
fled the Nazi regime, fears of fifth columnists
undermining the war effort led the British gov-
ernment to intern all German nationals in 1940.
Little is known about the Kahnweilers' intern-
ment in the Isle of Man. According to a friend,
Gustav later said that the conditions were not par-
ticularly bad. If so, it is possible that he may have
been designated a 'Class A' prisoner on account
of his socio-economic status, and allowed to pur-
chase certain comforts. Internees in the camps –
in some cases individuals who were or went on
to become leading figures in British cultural and
business life – organised lectures and entertain-
ments to help pass the time. Inevitably, however,
the camps were dominated by fear about what
would be the ultimate fate of the internees and
uncertainty about the whereabouts of loved ones.
 Partly, it seems, to help secure the release
of Elly, then interned in a women's camp at Port
Erin, Gustav volunteered in December 1940 to
join the Auxiliary Military Pioneer Corps as
a private. On his service form his 'trade on enlist-
ment' is given as 'retired art dealer', and under
the heading 'religion', 'Jewish' is crossed out and
replaced by 'agnostic'.[37] He would have joined one
of the several unarmed companies of 'aliens' that

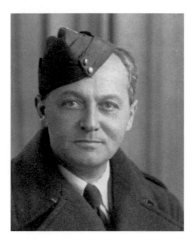

undertook non-combat projects such as guarding installations and heavy construction work. Following a medical in September 1941, Gustav's fitness category was downgraded and he was discharged a year later.

The German invasion of France had forced Daniel-Henry to flee south of Paris. In June 1940 Hitler ordered the seizure of art collections in France, and shortly afterwards the moving and selling of works of art without written authorisation was forbidden. As part of an Aryanisation programme the gallery was taken over by the authorities but, with Daniel-Henry's agreement, Louise Leiris, who had worked in the gallery for twenty years, came forward to purchase it, borrowing money from various friends and associates, including Picasso. Despite an anonymous letter to the authorities denouncing her as related to Kahnweiler, the sale went ahead, and the gallery was able to operate through the war under her name. Staying in the house owned by his brother-in-law, the artist Elie Lascaux, in the Haute-Vienne, Daniel-Henry – forced from May 1943 to wear a yellow star – consoled himself by writing *Juan Gris: Sa Vie, son oeuvre, ses écrits*. Published in 1947, this set out not only the life of his 'dear friend' but also his own vision of the aesthetic principles of cubism. He returned to Paris in August 1944 and slowly began to rebuild his business, working with Louise Leiris. From 1947 he once again had an exclusive contract with Picasso, buying anything that Picasso was willing to sell, as well as publishing his lithographs. This relationship was to prove the basis of the substantial fortune that Daniel-Henry Kahnweiler accumulated in the post-war years, and a probable later source of funds for Gustav.

The happier circumstances and more buoyant economy of the post-war years seem to have led Gustav to return to occasional dealing. The records of the Mayor Gallery show that Gustav jointly purchased a number of art works with Freddie Mayor (nearly always of Kahnweiler artists) in the years 1946–58; he also sold some works through the gallery. At the same time Gustav began to build up his own collection. He acquired a group of works – three Légers and two works by Laurens (nos.26, 27) – that had been deposited in England before the war. From the late 1940s his brother allowed him to have five of each edition of Picasso's lithographs at 'a friend's price'. These he bought together with the dealer Heinz Berggruen, who sold the prints through his gallery in Paris for a shared profit. (Berggruen had met Gustav and Elly Kahnweiler in 1948 or 1949, and saw them frequently on their trips to Paris, Switzerland and Italy. He also visited them in England, where they had as mutual friends the dealer Erica Brausen of the Hanover Gallery and the frame-maker Alfred Hecht.)[38] Gustav had good connections with friends and collectors of Paul Klee in Switzerland, notably his brother's close friend Hermann Rupf. Through them Gustav obtained many important works by Klee in the 1960s. Some of these he bought with Berggruen who then sold the works through his gallery.[39]

The Kahnweilers' later years were marked by friendship with the British sculptor Henry Moore, who enjoyed enormous international success in the post-war years. Postcards from Henry and his wife Irina sent in the 1950s and 1960s suggest a warm and convivial relationship. Moore sometimes sold his works privately, and Gustav

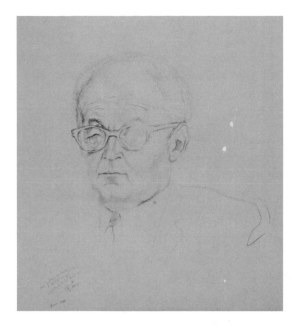

Kahnweiler was happy to act as an intermediary on his behalf. In 1952, for example, he was involved in the negotiation for the sale of a piece to the Kunstmuseum Basel.[40] In 1962 the Kahnweilers bought a major work from Moore entitled *Draped Reclining Woman* 1957–8 (no.45). They sited this in the grounds of their home but hoped that it might eventually be located in the gardens of the opera house at Glyndebourne. In a codicil to their will drafted that year – and reiterated in the 1974 Trust Deed – the opera-loving couple bequeathed the sculpture to the Tate Gallery on condition that it be lent to Glyndebourne for twenty-five years after their deaths, 'provided that in the opinion of the Trustees [of the Tate Gallery] the present standards of the Glyndebourne Arts Trust are maintained'.

Gustav and Elly were also close to the Italian artist Renato Guttuso. Guttuso was a member of the communist party for a period but opposed the style of socialist realism favoured by orthodox communism. He was banned from visiting America because of his politics, and at the same time was shunned by French communist circles because of his commitment to a form of post-cubist modernism. His approach, however, was particularly appreciated in Britain. The philosopher Richard Wollheim wrote that Guttuso was an artist who 'grasped one of the most important and revolutionary lessons of cubist painting: namely, that the realism of a picture can be enhanced by emphasising the reality of the painting.'[41] A man of wit and charm, Guttuso was fêted both by conservative and left-wing figures in Britain, and on visits to Britain in 1950 and 1955 met many of Britain's leading cultural figures, among them Bernard Berenson, Kenneth Clark, Herbert Read and Roland Penrose, as well as a number of young British artists. It is not known how Gustav and Elly came to be friends with Guttuso and his wife Mimise, but they often met in Italy and, from the evidence of inscriptions by Guttuso on a number of books on his work in the Kahnweilers' library, it would seem that they had a friendly relationship.

Gustav and Elly Kahnweiler began to consider leaving their collection to the Tate Gallery in the early 1960s. They were childless, and had no inclination to leave it to distant relatives or to any institution in Germany (Gustav was so wary of Germany that he refused to cross its borders until he could do so as a British citizen, following his naturalisation in 1947).[42] A deciding factor, however, was no doubt the cordial relationships the Kahnweilers enjoyed with successive Directors of the Gallery.

The first record of any contact between the Kahnweilers and Tate is a short note from the Director Sir John Rothenstein, dated 16 September 1951, enquiring if he might visit them in Cambridge at some point. Following a meeting Kahnweiler sent a business-like letter on 11 December, confirming that he was willing to lend the following pictures for a year: Gris's *Overlooking the Bay* (no.7), *Bottle of Rum and Newspaper* (no.6), *Pierrot with Book* (no.17), and four gouaches, together with Masson's *Pedestal Table in the Studio* (no.34); he subsequently added a work

by Picasso called *The Pedestal Table*. In a separate, more personal note, Kahnweiler spoke of his gratitude to the Tate for providing 'hospitality' for his works, and touched on matters relating to possible acquisitions that Rothenstein had discussed with him:

> *Personally I would like to thank you for the hospitality offered our Gris etc and we both would like to tell you again how much we enjoyed the visit of you and your family. Under separate cover I am going to send to you*
>
> > *7 photos after Lipchitz*
> > *26 " " Matisse*
> > *5 " " Lehmbruch*
>
> *The photos Matisse and Lipchitz arrived this very morning. I suppose Curt Valentin [a dealer based in New York and associate of Daniel-Henry] is coming over in 10 days time, and I am sure there is a possibility in case you are interested in buying bronzes by Matisse to get them not via New York but from France, so that payment can be made in French currency.*
> *I hope to see you before we leave for abroad, and I try to call on you in the first days of January. Kindest regards to your family.*[43]

In 1954 Kahnweiler added Masson's *Riez* (no.38) to the list of works available to the Tate, and asked for the items loaned to be credited to both him and Elly (roughly half the collection was in her name). From this point an informal arrange-ment, renewed each year, saw an increasing number of works coming to the Tate Gallery in January and returning to the Kahnweilers' home in Alderbourne Manor in May or June, when the couple returned from their travels abroad.

Having failed to demonstrate a clear commit-ment to international contemporary art in the inter-war and immediate post-war years, not least because of lack of funding, the Tate Gallery was anxious to make amends in the 1950s. The climate was not particularly propitious: in 1957 the Treasury turned down a request for a special grant to purchase a recent Braque and a Léger on the grounds that the works were 'controversial';[44] and subsequently it also refused to give a lump sum to help fill major gaps in the collection. However, at the very end of the 1950s and in the early 1960s the Gallery was able to make a series of major purchases of contemporary art, particu-larly American, as a result of increased public and private funding. Yet the gaps in the early modern period were glaring. This made the loan of the Kahnweiler collection of late cubist works all the more welcome, notwithstanding the difficulties involved in transporting the collection to and from Buckinghamshire twice a year and rehang-ing the galleries. In 1958 an Assistant Keeper wrote, 'I would particularly like both you and your wife to know how very much all of us and the public appreciate having your things here for such a long period every year, and we very much hope we shall be able to continue the

Fig.14
André Masson
Daniel-Henry Kahnweiler 1946
45 × 31
Inscribed 'To Elly and Gustav, affectionately Heini [Daniel-Henry], Christmas 1946'.
Tate Archive TGA 9223.2.5

arrangements in the future.'[45] For their part, the Kahnweilers were very aware of how useful the loans were to the gallery and were pleased to have their works, which inevitably were uninsured, kept in safety while they were out of the country.

In 1964 Norman Reid was appointed Director, and he and his wife Jean became personal friends of the Kahnweilers.[46] Gustav was keen to help the gallery expand its international collection: at one point, aware that the gallery wanted to extend its holdings of Laurens, he advised Reid not to wait for the forthcoming retrospective but to contact his brother to find out what works he could make available to the Tate.[47] This resulted in the Tate buying a major bronze, *Autumn* 1948, from the Galerie Louise Leiris. By 1967 the concept of a future bequest of the Kahnweilers' collection was being discussed formally, and the idea that some of the more minor works in it might be sold was mooted. In 1972 Gustav was awarded a CBE in recognition of his generosity. With all the remaining legal issues finally resolved, a Trust Deed was drawn up in 1974 whereby Gustav and Elly Kahnweiler retained a lifetime interest in a group of thirty-one works but legal ownership passed to three Gift Trustees (Norman Reid, the artist Howard Hodgkin and the collector E.J. Power),

who were to present the works to the Tate upon the death of the Kahnweilers.

Gustav Kahnweiler died in 1989, Elly in 1991. It was through her will as the last survivor that nearly all the remaining works of art in their joint estate passed to the Tate Gallery as part of the Gift. Based on detailed instructions provided by Gustav, with Elly's agreement, the will expressed the wish that works would not be retained as 'part of a reserve collection or otherwise permanently kept in storage so that they are never seen by the general public'. Such works, the will stated, were to be sold and the proceeds used to purchase a work or works by one of a group of named artists (Picasso, Braque, Léger, Gris, Klee, Miró and Moore). Fifty-five works entered the Tate's art collection in 1994 and a further six entered the Archive. Ninety-five works, some of uncertain attribution, were sold. The proceeds, together with the sum raised by the sale of Elly's personal effects, were put towards the purchase in 2003 of *The Billiard Table* 1945, (no.2) by Braque. Painted in a style that reflects Braque's masterful and highly individual interpretation of the formal language of cubism, this work may be seen as a fitting tribute to Gustav and Elly and their love of art that sprang from this influential movement, so closely associated with their family name. A modest man, Gustav never dwelt on his connections with key figures in the Paris art world, but the gift of his and his wife's collection ensured a permanent association between the British national collection of modern art and the remarkable story of the Kahnweiler family.

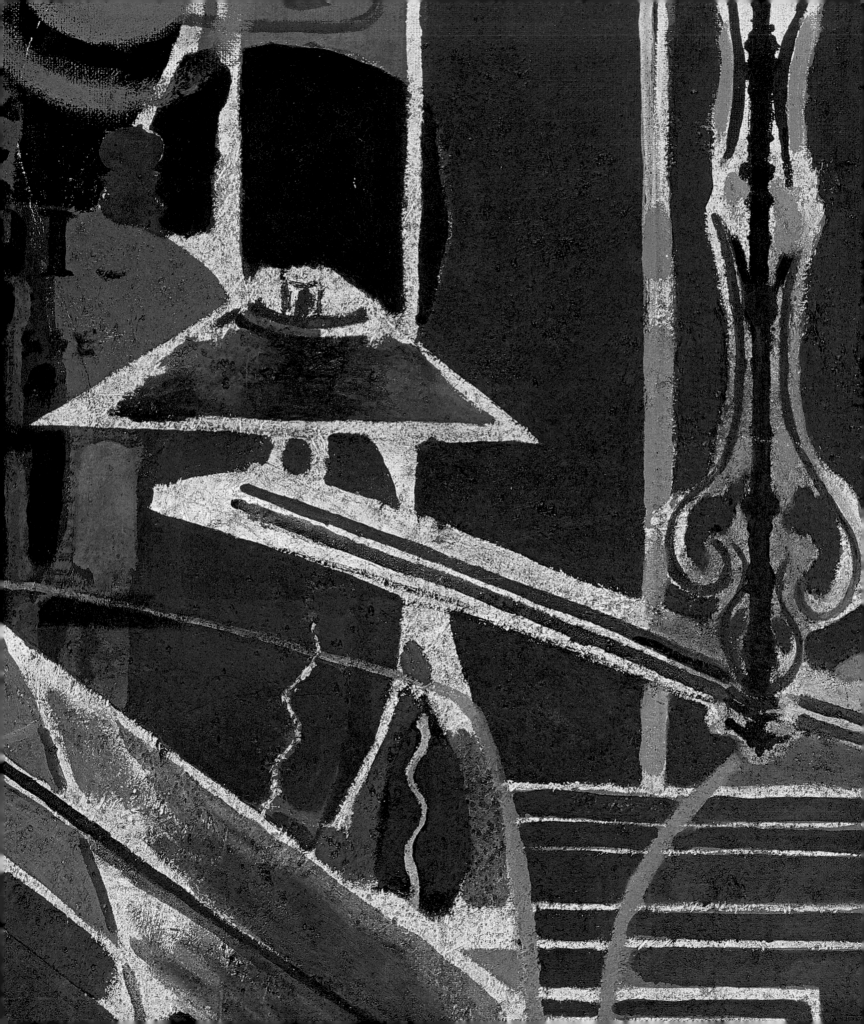

Georges Braque 1882 – 1963

Georges Braque was one of the first artists bought by Daniel-Henry Kahnweiler and, though their personal relationship was to cool somewhat after the First World War, Braque was always to remain an artist of capital importance for the dealer.

Kahnweiler first met Braque in April 1907 and soon offered to buy all the works that the artist had in his studio. An informal agreement, sealed with a handshake, secured all of Braque's production in exchange for a monthly stipend and fixed rates of payment per work, until 1912 when a formal contract was signed. In the early years of cubism, Kahnweiler and Braque saw a great deal of each other, with Kahnweiler dropping in to see Braque and his other artists working nearby in the morning, and Braque coming with Picasso to the gallery for a chat at the end of the working day. In 1908 Kahnweiler broke his own rule of not promoting an artist through a solo exhibition in order to help Braque when the latter found himself in the ignominious position of having his paintings refused by the Salon d'Automne. Kahnweiler organised a show of Braque's works in his gallery on the rue Vignon, with a catalogue essay written by the poet Apollinaire.

Kahnweiler's affection for Braque was undimmed through the war years. While living in Bern with almost no contact with his friends in France, Kahnweiler came across a text published by Braque, 'Thoughts and Reflections on Painting'. He admired it so much that he translated it into German and sent it to what he considered the most progressive art journal in German, *Das Kunstblatt*. With the ending of the war Kahnweiler immediately attempted to woo Braque, asking him to send paintings formerly contracted to him to Switzerland so that he might begin to sell them to his clients. When Kahnweiler returned to Paris in 1920, Braque willingly accepted a contract with him, while keeping the right to retain and sell privately five canvases a year. Braque also did what he could to prevent the forced sale of Kahnweiler's stock. Indeed, he felt so strongly about this issue that he publicly hit his own wartime dealer Léonce Rosenberg for siding with the authorities over the sale.

For his part, Kahnweiler truly admired Braque. During this period he took notes of his conversations with Braque about art, still wanting to be the intellectual as well as commercial defender of the key artists of his generation. However, Braque was

becoming increasingly successful and well known, and felt that his paintings were worth more than Kahnweiler willingly offered. In 1923 he moved to the more conservative and upmarket Paul Rosenberg Gallery. He had already ceased his friendship with Picasso, and so disliked the work of Juan Gris that, in the Salon des Indépendants, he had refused to let his works hang in the same room. The camaraderie of the cubist group had ended, though Daniel-Henry continued to call all the major figures of cubism his friends throughout his life.

It is not known if Gustav Kahnweiler had any direct dealings with Braque in the inter-war years or when he obtained the still-life drawing of 1924 (no.1), a date at which his brother no longer represented the artist. Works by Braque were included in some of the mixed shows of Parisian art held at Flechtheim's Berlin gallery,[1] no doubt through Daniel-Henry Kahnweiler who, though no longer Braque's exclusive representative, continued to show and sell his works. Proof of Daniel-Henry Kahnweiler's continued affection for Braque can be seen in his gift of a lithograph *Helios V* (no.3), to his brother, which he presumably bought from Aimé Maeght, Braque's dealer after the Second World War and publisher of his prints. JM

1
Georges Braque
Still Life 1924
Nature morte

Charcoal and pencil on paper
29.5 × 35
Signed 'G Braque | 24' b.l. in pencil
T06804
Bequeathed by Elly Kahnweiler
1991 to form part of the gift of
Gustav and Elly Kahnweiler and
accessioned 1994

Provenance
... ; Gustav and Elly Kahnweiler
(Galerie Louise Leiris is unable to
ascertain whether this work passed
through Galerie Simon as no gallery
number is known for this work)

The Billiard Table 1945

The Billiard Table is a magisterial example of the late style of Georges Braque. With its subtle, and characteristic, colour harmonies of greens, greys and browns, and its free use of line, plane and descriptive detail evoking an interior scene, the canvas epitomises many of the qualities for which the French painter was revered in his lifetime.

It is one of a series of seven paintings on the subject of a billiard table. The series was begun in 1944; exactly when is unknown, though quite possibly after the liberation of Paris in August. Certainly, the sheer boldness and playfulness of the series stands in marked contrast to the typically more sober and smaller works that Braque executed during the years of German occupation. As to the subject of the series, Claude Laurens, son of the artist Henri Laurens – who was a close friend of Braque and regular visitor to his home – said that Braque did not own a billiard table. He claimed the motif may have been based only on a youthful memory.[2] Another witness from this period suggested that Braque continued to play billiards long beyond his youth in the company of his brother-in-law.[3] For an artist working in the vein of late cubism, however, direct observation had little role to play in the genesis of paintings.

Whatever prompted Braque to tackle this unlikely subject – presaged in modern art only by some works by Van Gogh – it seems possible that he was drawn to do so partly by the challenge of depicting the massy, architectural form of a full-size billiard

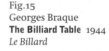
Fig.15
Georges Braque
The Billiard Table 1944
Le Billard

Oil and sand on canvas
130.5 x. 195.5
Musée national d'art moderne,
Centre Georges Pompidou, Paris

table without recourse to traditional perspective. In the words of Bernard Zurcher, Braque 'needed no less than seven rounds (to use a metaphor from boxing, a sport that Braque used to practice) to overcome this theme and break its resistance'.[4] Another writer, Dennis Adrian, suggested that the billiard table motif could also be seen as an unexpected reprise of the traditional theme of a 'painting within a painting'. Like a canvas, a billiard table is a flat rectangular surface covered with cloth; the cues – like paintbrushes – are sticks manipulated by hand, to which something (chalk/bristles) has been added, and like painting involves the movement of coloured elements (balls/paint) with both predicted and unpredicted effects. 'If Braque's imagery does play an allusive and associational role,' Adrian wrote, 'the billiard table might be construed as an ingenious and convincing symbol for painting [...] The larger meaning of the billiard table

can then be construed as an idea of painting as a sublime game, a *jeu artistique*, in which the process of the game, as well as its outcome, offers a field for aesthetic appreciation.'[5]

The series, executed between 1944 and 1952, consists of three large paintings (each almost 2m in one direction), this medium-sized work, and three much smaller and less ambitious canvases. The three large works all appear to deal with a specific pictorial challenge. The earliest, owned by the Centre Georges Pompidou, Paris, shows the billiard table surprisingly bent up on an axis in line with the corner of the room (fig. 15). The shared axis links the foreground and background in a way that underscores the shallowness of the pictorial space and the flatness of the painting's surface. The second large work was begun at the same time but only finished in 1952. This latter work, owned by The Metropolitan Museum, New York, is a tall

2
Georges Braque
The Billiard Table 1945
Le Billard

Oil and sand on canvas
89.1 × 116.3
Purchased with assistance from the
gift of Gustav and Elly Kahnweiler,
the National Art Collections Fund,
Tate Members and the Dr V.J. Daniel
Bequest 2003
T07992

Provenance
Inherited from the artist by
Claude Laurens, Paris, 1963; pur-
chased by Galerie Louise Leiris, Paris,
2002, by whom sold to Tate 2003

but narrow painting. It shows the billiard table tipped up vertically and 'pinched' in the middle to make an hourglass shape, creating an impossibly abrupt spatial recession. In the third work, owned by the Museo de Arte Contemporanea de Caracas and variously dated 1947–9, 1948–9 and 1949 but probably completed in 1948, the billiard table is no longer spatially distinguished from its surrounding space: lines extend horizontally across the canvas suggesting the movement of the billiard cues beyond the picture frame; and birds seem to advance from the background wallpaper to exist in the same plane as the table itself.

Probably painted in the early months of 1945,[6] Tate's *Billiard Table* is closely related to the Paris work. It, too, shows a horizontal billiard table tipped up towards the viewer and 'bent' at approximately two-thirds of its distance across; and it, too, has three billiard balls, and a cue in a roughly similar position. However, it is a more complex composition, with added decorative elements and a more detailed background. The lattice window in the Paris work is replaced by an abacus, and instead of a large potted plant on a round table there is a more modest vase on a rectilinear table subsumed in the detailed panelling on the background wall. The hat stand on the left of the earlier painting is replaced by a straw boater, a feature of both the Caracas and the New York pictures. The hat, scarf and curving line suggestive of shoulders – perhaps a coat hung over a chair – create an anthropomorphic

presence in this work. Although the interiors in all the other works of the series seem emphatically domestic, the hanging lights and what might be a poster (or perhaps sheet music) with lettering that could be read as 'Loi sur l'ivresse' (Law against drunkenness), distantly evoke the interior of a billiard hall. The presence of lettering also recalls the snippets of words, and wordplays, found in Braque's and Picasso's early cubist works.

Memories of previous paintings seem to inform a number of the shapes and patterns in this work, and can be seen as part of the repertoire of motifs with which Braque built his compositions. The unexplained but dominant grey outline shapes in the centre of this picture, for example, were present in the Paris version, but were more closely linked to a descriptive role: the curve embraced the round table, while the upright elements flattened and linked the pictorial space at the point where the table was bent. Perhaps derived from the shapes of chair backs seen from an angle, or of plants, the same forms are also found dominating an earlier painting *Interior with Palette* 1942 (Menil Collection, Houston).

The freedom to invent and to depart from realism was central to Braque's approach to painting. Although he worked out the basic details of his compositions in preliminary drawings, he liked to describe his working method – or perhaps more exactly, the pleasure he derived from painting – as being based on pictorial discoveries. 'I never know how it will come out.

The picture makes itself work under the brush', he said. 'A picture is an adventure each time.'[7] He was also adamant in his belief that the introduction of perspective and naturalist depiction in the Renaissance era represented a cul-de-sac in the history of art. Always preferring to express his views in condensed, epigrammatic form, he wrote, 'Illusionism is only a visual trick' and 'You must not imitate what you want to create'. These maxims, taken from his notebooks, were published in the frontispiece of a 1958 catalogue of Braque's prints, with five short poems by René Char. Braque, who was a close friend of Char and of other leading poets, saw the allusive and metamorphic quality of his style as inherently poetic. The sequence of maxims ended with, 'Thus a poet can say a swallow knifes the sky and make of the swallow a knife'.[8] The poetic, of course, expressed a certain philosophical stance towards the world.

Late in life Braque told the author John Richardson, 'I have made a great discovery. I no longer believe in anything. Objects don't exist for me except in so far as a rapport exists between them and myself. When one attains this harmony one reaches a sort of intellectual non-existence – what I can only describe as a sense of peace, which makes everything possible and right. Life then becomes a perpetual revelation. That is true poetry.'[9] JM

3
Georges Braque
Helios V 1948

Lithograph on paper
50.2 × 42.5
Inscribed 'G Braque | 62/75' b.r.
in black chalk and 'Pour Gustave |
avec mon affection | Heini' b.c.
in blue ink
Presented by Gustav and
Elly Kahnweiler 1974 and
accessioned 1994
P11369

Provenance
Galerie Maeght, Paris; ... Daniel-
Henry Kahnweiler, by whom
given to Gustav Kahnweiler

César 1921–1998

César started to receive international recognition for his work as a sculptor in the 1950s. Major catalysts in this process were his participation at the 1956 Venice Biennale with four works and winning the Third Carnegie Prize for sculpture in Pittsburgh and a silver medal at the Universal Exhibition in Brussels in 1958.

It is not known if there was a personal connection between César and Gustav and Elly Kahnweiler, though it is possible that the Kahnweilers came to hear of him through the critic Douglas Cooper, who wrote the first monograph dedicated to César in 1960.

A grid of etched lines suggestive of a barred window, this untitled work is related to the flat welded iron *Plaques* that the artist started constructing in the mid-1950s. These *Plaques* were the result of César's exploration of frontality in sculpture and prefigured his monumental constructions of the 1980s. GB

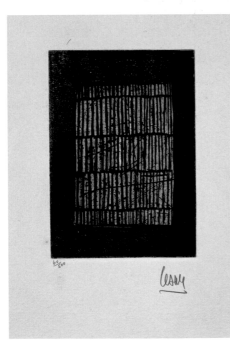

4
César
Untitled 1958

Etching on paper
14.8 × 10.6
Inscribed 'Cesar' b.r. in pencil
and '60/500' b.l. in pencil
Bequeathed by Elly Kahnweiler
1991 to form part of the gift
of Gustav and Elly Kahnweiler
and accessioned 1994
P11374

Provenance
... ; Gustav and Elly Kahnweiler

Cecil Collins 1908–1989

Cecil Collins and the Kahnweilers appear to have met in Cambridge. The name Kahnweiler first appeared in Collins's diaries in 1947 and reappeared sporadically until 1957, occasionally with the time for an appointment or a reminder to telephone.[1] The nature of the relationship between the artist and the Kahnweilers is not known, but it seems that Collins thought of Gustav as an interesting contact. In his notebooks there are occasional tantalising references to the collector, such as 'Exhibitions via Kahnweiler | Paris, London, New York' or 'Kahnweiler intros Paris London Rome Venice'.[2]

This lithograph was made at the Central School of Art, London, where Collins started teaching in 1951, and depicts Collins's wife Elisabeth in profile, wearing a medieval-style cap. Collins had an interest in the art of the distant past: the author Richard Morphet has written that the artist felt 'closer to a pre-Renaissance view of art than to most of that of the past five or six hundred years.'[3] GB

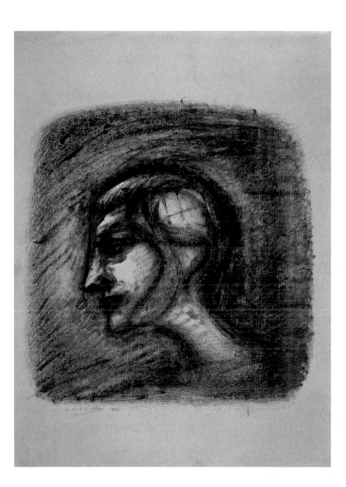

5
Cecil Collins
Portrait of the Artist's Wife 1955

Lithograph on paper
39.5 × 38
Inscribed 'Cecil Collins 1955' b.l. in pencil and '5/5' b.r. in pencil
Bequeathed by Elly Kahnweiler 1991 to form part of the gift of Gustav and Elly Kahnweiler and accessioned 1994
P11373

Provenance
… ; Gustav and Elly Kahnweiler

Juan Gris 1887–1927

For Daniel-Henry Kahnweiler, Gris, along with Braque, Picasso and Léger, was one of the four great cubist artists. Kahnweiler found in the Spaniard's work 'all the essential qualities which constitute the historic importance of cubism'[1]. Besides, he wrote, 'In his art, more than in anyone else's, we have proof that cubism, far from wishing to "burn down the Louvre", was merely the continuance of the authentic tradition of painting'.[2]

Juan Gris – as José Victoriano Gonzalez was known – came to Paris from Madrid in 1906. He supported himself by working as an illustrator and lived in the Bateau Lavoir, a ramshackle and shabby block of flats and studios in Montmartre. His studio was close to that of Picasso and the two men became friends. Gris took up oil painting in 1911 and began almost immediately to paint in a cubist style, influenced by his friendship not only with Picasso but also with Braque. In the following year he showed cubist works in an exhibition called the Section d'Or, alongside artists such as Marcoussis, Gleizes and Metzinger. He was thought by many the most gifted of the group. The American writer Gertrude Stein bought a work, as did the dealer Léonce Rosenberg. It was at this point that Daniel-Henry Kahnweiler offered Gris a contract, which was agreed in 1913.

Curiously, Kahnweiler did not include Gris in *Der Kubismus*, which he wrote in 1914–15. Perhaps he was not certain of Gris's significance at this stage, although the poet Apollinaire had already mentioned Gris in his volume *Les Peintres cubistes* of 1913. During the war years, however, Gris gained confidence and experience. Kahnweiler was later to say that in 1914 he had left a young painter whose works had interested him and had found on his return to Paris in 1920 a 'master'. He also recalled that in the war Gris had been the only one of his painter friends to write to him – a German who could no longer return to France – and noted that 'his courage in doing so must not be overlooked'.[3]

In the 1920s Gris relied on Kahnweiler for both financial and moral support. Kahnweiler provided the money that Gris badly needed, and responded to Gris's frequent requests for advice and opinions with respectful but always frank views. In 1922 he found Gris and his companion Josette a place to live almost next to his

own home in Boulogne-sur-Seine, and from then on Gris was very much part of Kahnweiler's family circle. He was a regular at Kahnweiler's celebrated Sunday gatherings, to which were invited friends including Kahnweiler's financial backer André Simon, the critic Maurice Raynal, the artist André Masson, the composer Erik Satie, and such promising young writers as Antonin Artaud, Max Jacob, Tristan Tzara, Robert Desnos and Michel Leiris. Kahnweiler later recalled: 'Gris was present at all these gatherings. There would be dancing to the gramophone which he brought with him – in the garden in summer, in the hall in winter. People came and went between the two houses as in turn they visited the studio to look at his latest pictures. After supper we talked, played, and sang.'[4] It is likely that Gustav Kahnweiler met Gris while visiting his brother's home.

Although not as inventive as Picasso or Braque, Gris brought a rigour to his handling of the pictorial problems posed by cubism and this in turn helped him form his distinctive style. His approach to art was always meditative and highly disciplined. He once wrote to Kahnweiler, 'I hope I shall come to express with great precision a reality imagined in terms of pure intellectual elements'.[5] For all the novelty of his cubist imagery, Gris saw his technique as essentially classical and based on that of the old masters.

Gris did not enjoy much critical esteem or commercial success in his lifetime, though he was revered by his close friends. Kahnweiler gave him only one exhibition in Paris but assiduously promoted his work abroad, particularly in America and, through Alfred Flechtheim, in Germany. After Gris's premature death in 1927, Kahnweiler put on a retrospective at the Galerie Simon and was a key figure in helping to stage many later retrospectives in other countries. During the German occupation of France in the Second World War, when he was obliged to leave Paris, Kahnweiler found consolation in writing a lengthy monograph on the artist of whom he had such fond memories. In this he described Gris as 'the purest of men, the most faithful and tender friend I have ever known, and one of the noblest artists ever born'.[6] JM

6
Juan Gris
Bottle of Rum and Newspaper
1913 – 14
Bouteille de rhum et journal

Oil on canvas
46 × 37
Presented by Gustav and
Elly Kahnweiler 1974 and
accessioned 1994
T06808

Provenance
Daniel-Henry Kahnweiler
(Galerie Kahnweiler, Paris,
stock number 5037); purchased
by Gustav Kahnweiler 1922
(letter from Galerie Louise Leiris,
Paris, to Tate, 26 May 2000)

Bottle of Rum and Newspaper 1913 – 14

Gris first began to paint in a cubist manner in 1912 and, under the influence of his close friends Picasso and Braque, he quickly progressed through 'analytical' cubism, with its faceted forms and shifting perspectives, to 'synthetic' cubism, using overlapping flat planes of colour and texture.

In this most radical form of the cubist idiom, nature was no longer a necessary starting point. Instead, coloured planes provided the architecture for imagery that the artist could develop towards something representative. Daniel-Henry Kahnweiler wrote of Gris's method, 'He started with the ensemble, whose rhythm he allowed to develop freely. From this rhythm sprang, in their turn, the objects. A few simple "stimulants" sufficed to make the spectator "see" the desired object. Parallel lines drawn on a white surface changed it into a page of music; lines of type turned it into a newspaper; a flatly drawn ring made it into a plate.'[7] Objects in such works were often no more than signs, which had to be read imaginatively by the spectator in order to be understood.

In *Bottle of Rum and Newspaper* Gris constructed the image from intersecting angular planes. Many of these have fake wood grain, suggestive perhaps of a wooden table top, though the way they overlap and interlock denies any possibility of recession or perspective. The bottle and the newspaper are indicated with a bare minimum of clues: a few letters, an outline and hint of local colour are sufficient to suggest the identity of the objects. The complexity of the work, however, lies in the suggestion that the overlapping and interpenetrating planes may represent to some degree visual memories of different views on to the objects. Such a painting, Kahnweiler was to insist, was conceptual in the sense that it was to be understood fully only through the use of the spectator's imagination. JM

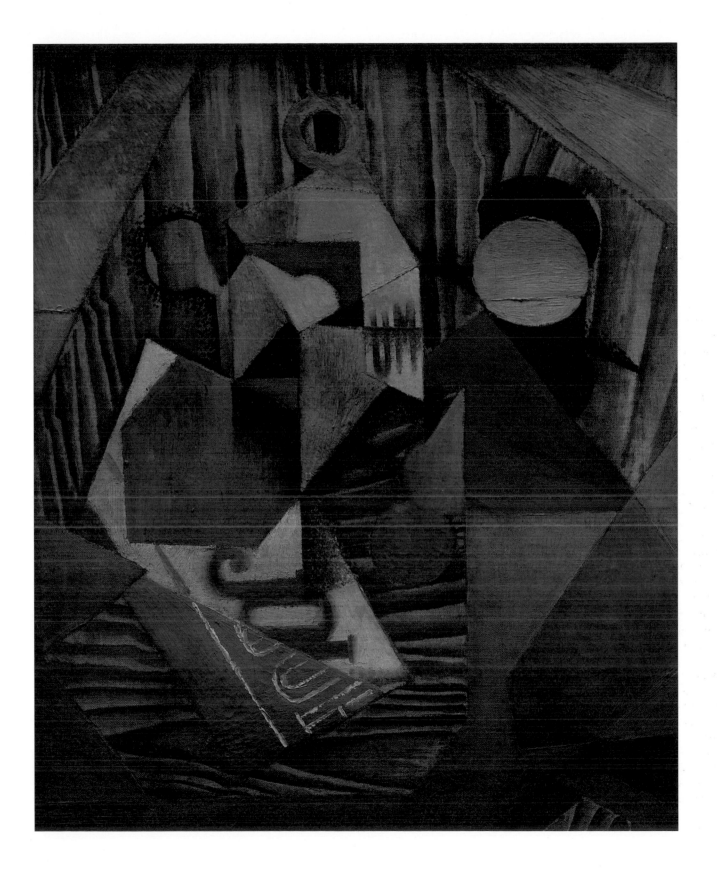

Overlooking the Bay 1921

'The sun is wonderful, but what a sinister landscape. Everything – the sea, the mountains – is as beautiful as can be, but how sad! ... The temperature here is very agreeable, but in bright sunlight the countryside looks gloomy.'[8] These were Gris's first impressions of Bandol, a small port and resort near Toulon, in the Var region of France, to which he and Josette had gone on medical advice, to avoid the cold and the damp of a winter in Paris.

They rented a room with a terrace overlooking the bay, and Gris found an attic in which to paint. Although he seems to have been sensitive to the contrast between the relative darkness of his apartment and the light outside, and to the somewhat depressing nature of the countryside, he set to work quickly. His first pieces were lithographs of local people, including a young boy who worked as his assistant (see nos.8–10). However, he soon began to work on a group of marine-format paintings featuring still life objects and architectural elements set in front of views of the bay at Bandol. On 15 January 1921 he wrote to Daniel-Henry Kahnweiler, 'the canvases on which I am working are well composed and the colour contrasts are less strong than before. I prefer them as far as the colour goes although they are subtler and less strongly coloured.'[9]

Overlooking the Bay shows a number of items commonly found in cubist still lifes – bottle, glass, newspaper, fruit dish – set against the blue sea and distant hills of a seascape. Moving away from the shallow space associated with pre-war cubism, Gris attempted here to allow foreground and distant background elements to co-exist without use of naturalistic perspective or chiaroscuro. It is a painting of controlled internal tension. No obvious logic underpins the relationship of the curtain, which hangs parallel to the picture plane, and the jutting angle of the window frame on the right. The solidity of the glass is contested by the schematically delineated bottle and by the bunch of grapes that looks as if it is a cut-out illustration collaged on to the canvas. Yet the image is held together by subtly rhyming shapes and the use of a palette of carefully modulated blues and greens. In such works Gris showed how far he had moved away from pre-war cubism while remaining absorbed in the problems of representation, space and light that were central to the style. Cubism, he later said, was not a manner of painting but 'an aesthetic, and even a state of mind'.[10]

Unexpectedly, it was Josette's ill-health, rather than Gris's fragile physical condition, that forced them to return to Paris in the summer of 1921. An infection in her thumb led to a minor amputation and septicaemia. Gris wrote to Kahnweiler on 10 June, 'I see that the climate here is not good for her and she's wasting away under my eyes. I was even going to send you two pictures, a size 31 and a size 40, which are finished, but I shall bring them myself instead.' Of the size 40 he said, 'I am particularly pleased with [it] because I think it is the best thing I have done here'.

This work, called *The View across the Bay,* was retained by Daniel-Henry Kahnweiler for his own collection, while the first mentioned size 31 canvas, *Overlooking the Bay,* was bought by Gustav Kahnweiler in 1922.[11]

JM

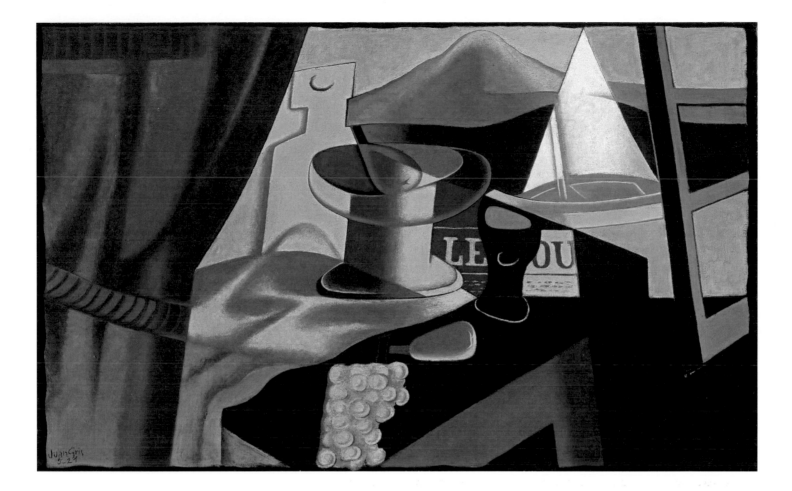

7
Juan Gris
Overlooking the Bay 1921
Devant la baie

Oil on canvas
63.5 × 96.5
Inscribed 'Juan Gris |
5–21' b.l. in black paint
Presented by Gustav and
Elly Kahnweiler 1974
and accessioned 1994
T06810

Provenance
Daniel-Henry Kahnweiler, Paris
(Galerie Simon, Paris, stock
number 58.117); purchased by
Gustav Kahnweiler 1922 (letter
from Galerie Louise Leiris, Paris,
to Tate, 26 May 2000)

8
Juan Gris
Blonde Marcelle 1921
Marcelle la blonde

Lithograph on paper
32 × 23
Inscribed 'Juan Gris 20/50'
b.r. in pencil
Bequeathed by Elly Kahnweiler
1991 to form part of the gift of
Gustav and Elly Kahnweiler and
accessioned 1994
P11370

Provenance
Daniel-Henry Kahnweiler (Galerie
Simon, Paris); purchased by
Gustav and Elly Kahnweiler 1921
(letter from Galerie Louise Leiris,
Paris, to Tate, 26 May 2000)

9
Juan Gris
The Boy 1921
Le Gosse

Lithograph on paper
37 × 28
Inscribed 'Juan Gris 31/50' b.l.
in pencil and 'Kahnweiler'
b.r. in pencil
Bequeathed by Elly Kahnweiler
1991 to form part of the gift of
Gustav and Elly Kahnweiler and
accessioned 1994
P11371

Provenance
Daniel-Henry Kahnweiler (Galerie
Simon, Paris); purchased by
Gustav and Elly Kahnweiler 1921
(letter from Galerie Louise Leiris,
Paris, to Tate, 26 May 2000)

10
Juan Gris
Jean the Musician 1921
Jean le musicien

Lithograph on paper
36 × 24
Inscribed 'Juan Gris 46/50' b.l.
in pencil and 'Kahnweiler'
b.r. in pencil
Bequeathed by Elly Kahnweiler
1991 to form part of the gift of
Gustav and Elly Kahnweiler and
accessioned 1994
P11372

Provenance
Daniel-Henry Kahnweiler (Galerie
Simon, Paris); purchased by
Gustav and Elly Kahnweiler 1921
(letter from Galerie Louise Leiris,
Paris, to Tate, 26 May 2000)

11
Juan Gris
Seated Harlequin 1920
L'Arlequin assis

Pencil on paper
34.2 × 27
Inscribed 'Juan Gris 1–20'
b.r. in pencil
Presented by Gustav and
Elly Kahnweiler 1974 and
accessioned 1994
T06809

Provenance
... ; Gustav and Elly Kahnweiler
by July 1952 when lent to the
Tate Gallery

12
Juan Gris
Guitar and Music Book 1923
Guitare et cahier de musique

Ink on paper
15.6 × 23.8
Inscribed 'Juan Gris' b.r. in pencil
Presented by Gustav and
Elly Kahnweiler 1974 and
accessioned 1994
T06811

Provenance
Daniel-Henry Kahnweiler (Galerie
Simon, Paris, stock number 168b);
purchased by Gustav and Elly
Kahnweiler by January 1957 when
lent to the Tate Gallery

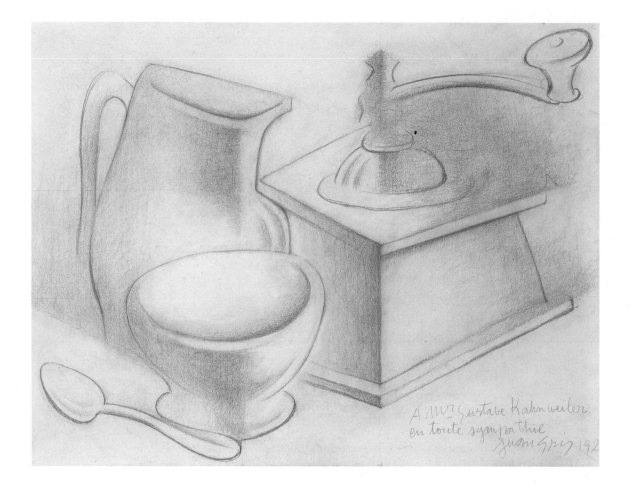

13
Juan Gris
Coffee Mill 1924
Moulin à café

Pencil on paper
26.8 × 34.7
Inscribed 'A M. Gustave
Kahnweiler | en toute sympathie
| Juan Gris 1927' b.r. in pencil
Bequeathed by Elly Kahnweiler
1991 to form part of the gift of
Gustav and Elly Kahnweiler and
accessioned 1994
T06816

Provenance
Acquired by Gustav Kahnweiler
1927

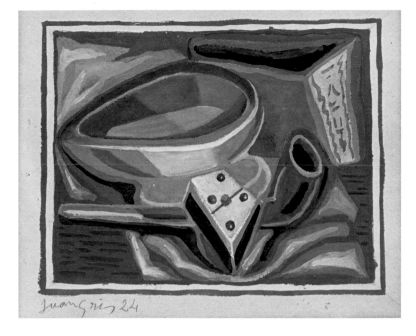

14
Juan Gris
Pipe and Domino 1924
Pipe et domino

Gouache on paper
18 × 22.3
Inscribed 'Juan Gris 24'
b.l. in pencil
Presented by Gustav and
Elly Kahnweiler 1974 and
accessioned 1994
T06812

Provenance
Daniel-Henry Kahnweiler (Galerie
Simon, Paris, stock number 8577);
purchased by Gustav Kahnweiler
1924 (letter from Galerie Louise
Leiris, Paris, to Tate, 26 May 2000)

15
Juan Gris
Still Life with Guitar 1924
Nature morte à la guitare

Gouache on paper
23.6 × 18.4
Inscribed 'Juan Gris 24'
b.l. in pencil
Bequeathed by Elly Kahnweiler
1991 to form part of the gift of
Gustav and Elly Kahnweiler and
accessioned 1994
T06815

Provenance
Daniel-Henry Kahnweiler (Galerie
Simon, Paris, stock number 8574);
purchased by Gustav Kahnweiler
1924 (letter from Galerie Louise
Leiris, Paris, to Tate, 26 May 2000)

16
Juan Gris
Bowl of Fruit 1924
Compotier

Gouache on paper
18.3 × 22.9
Inscribed 'Juan Gris 24'
b.l. in pencil
Presented by Gustav and
Elly Kahnweiler 1974 and
accessioned 1994
T06813

Provenance
Daniel-Henry Kahnweiler (Galerie
Simon, Paris, stock number 8576);
purchased by Gustav Kahnweiler
1924 (letter from Galerie Louise
Leiris, Paris, to Tate, 26 May 2000)

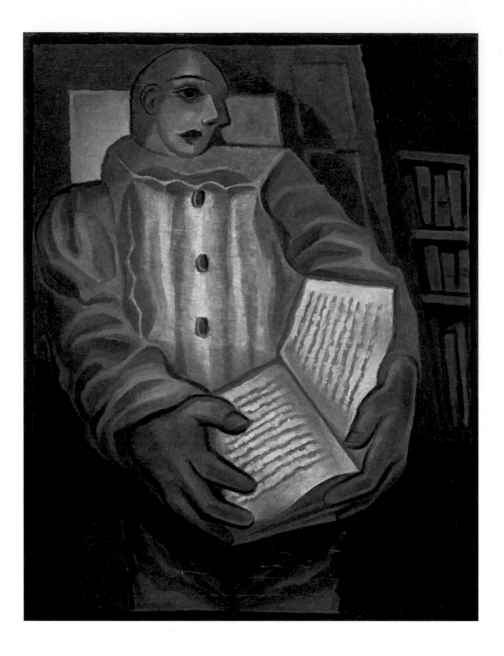

17
Juan Gris
Pierrot with Book 1924
Le Pierrot au livre

Oil on canvas
65.5 × 50.8
Inscribed 'Juan Gris | 24' b.l.
in black paint
Bequeathed by Elly Kahnweiler
1991 to form part of the gift of
Gustav and Elly Kahnweiler and
accessioned 1994
T06814

Provenance
Daniel-Henry Kahnweiler (Galerie
Simon, Paris, stock number L606);
purchased by Gustav Kahnweiler
1924 (letter from Galerie Louise
Leiris, Paris, to Tate, 26 May 2000)

Renato Guttuso 1912–1987

Following the fall of the fascist regime and the end of the Second World War, Italy became a democratic Republic for the first time and Renato Guttuso, having taken part in the resistance, resumed his activities as a painter and critic. A prominent artist who had been considered controversial by the fascists, Guttuso was described in 1955 by the critic John Berger as 'the most significant European painter of the post-war period'.[1] By this time he had became one of the main protagonists in debates about figuration and abstraction in Italy and abroad. In March 1955 he took part in a high-profile debate on realism versus abstraction, with Patrick Heron putting the case for abstraction and Ernst Gombrich as chair, at the Italian Institute in London.[2] Guttuso's own – figurative – work in the 1940s and early 1950s demonstrated his belief that art should 'have a direct effect on the life of all men'.[3] According to the art historian Enrico Crispolti, this was Guttuso's 'social realist' period, followed in the late 1950s and early 1960s by a less overtly political 'existential realist' phase.[4] In 1956 the artist wrote about creatively reconstructing 'the real' and 'the necessity to give shape to general situations of revolt, of horror, of joy, of eroticism, of destruction, in a panic order in which feelings are no longer tied to the man or the fact that generates them, but to a general human condition'.[5]

Guttuso's reputation in Britain grew after his works at the 1948 Venice Biennale elicited enthusiastic reviews from leading British critics such as Douglas Cooper and Herbert Read.[6] The same year John Fleming wrote an essay on Guttuso for the cultural journal *Penguin New Writing*, declaring that his importance lay in the way he had 'understood and assimilated the problems of the cubists and post-cubist painting'.[7] In 1950 Guttuso went to London for his first British exhibition, at the Hanover Gallery, and met many major figures in the British art world, including Henry Moore, Roland Penrose and Graham Sutherland.[8] In November of the same year, however, he was 'one of the many Communist intellectuals' to be refused entry into the country when he tried to attend the Sheffield Peace Conference as a delegate.[9]

It is known that the Kahnweilers were friendly with Guttuso by the mid-1950s, when the artist inscribed the Kahnweilers' copy of a monograph dedicated to him 'To Eli [sic] and Gustavo [sic] Kahnweiler with Guttuso's friendship, Rome 24 May 55'.[10]

Fabio Carapezza Guttuso, the artist's adopted son, has said that his father met Kahnweiler at Picasso's home.[11] Guttuso had first met Picasso in 1946 in Paris. Gustav and Elly regularly visited the Guttusos in Italy and at least on one occasion, in May 1963, they spent time together while on holiday on the island of Ischia.[12] In January 1964 the Kahnweilers made a special trip to Parma to see Guttuso's first major retrospective and the artist's inscription in their copy of the exhibition catalogue testifies to the strength of their friendship at this point: 'To Ely [*sic*] and Gustav with all my affection and gratitude for their visit to my exhibition. Renato, Parma 21.1.64'.[13] Gustav's brother Daniel-Henry also knew Guttuso and was a member of the exhibition's Honorary Committee, which included Giulio Carlo Argan, Palma Bucarelli, Douglas Cooper, Carlo Levi, Alberto Moravia and Pier Paolo Pasolini. GB

18
Renato Guttuso
Nude 1959
Nudo

Crayon on paper
73 x 51
Inscribed 'Guttuso '59'
t.r. in black crayon
Presented by Gustav and
Elly Kahnweiler 1974 and
accessioned 1994
T06830

Provenance
Purchased by Gustav and
Elly Kahnweiler by January 1960
when lent to the Tate Gallery
(communication from Fabio
Carapezza Guttuso, Rome,
to Tate, 4 October 2003)

19
Renato Guttuso
Santa Panagia (Sicily) 1956

Oil on canvas
69.1 × 78.1
Inscribed 'Guttuso '56'
b.r. in red paint
Presented by Gustav and
Elly Kahnweiler 1974 and
accessioned 1994
T06829

Provenance
Purchased by Gustav and Elly
Kahnweiler by January 1958 when
lent to the Tate Gallery (commu-
nication from Fabio Carapezza
Guttuso, Rome, to Tate, 4 October
2003)

Still Life in the Studio 1962

During the last years of fascist rule Guttuso focused on violent still lifes that functioned as covert symbols of his political dissent. Painted in bright, expressionistic colours, these still lifes featured objects such as nails, birdcages, knives and flag-like red cloths. They often contained citations of the work of other artists, such as the recurring opaline bottle, a reference to Giorgio Morandi, and animal skulls, a homage to Picasso who, since painting *Guernica* (1937), had become a symbol of anti-fascism for many dissenting artists in Italy. Guttuso stated, 'since 1937 Picasso had been our flag, more than a master, more than a name we repeated, [he was] a symbol: for us he personified the fight for freedom of artists, "committed" culture, all those ideas that we were starting to develop about our very *raison d'être* as painters'.[14]

Still life was one of Guttuso's favourite themes and he returned to it throughout his career. Like many of the works from the fascist period, this ink drawing explores the subject of the still life in the artist's studio. However, it does not have the same ideological import as the earlier still lifes and is more in tune with Guttuso's postwar 'existential realism'. In this period, as Crispolti has said, at this time Guttuso was chiefly concerned with 'the individual and collective existential condition in a society of mass consumerism.'[15]

Still Life in the Studio is uncharacteristically muted in colour, although this is partly due to the light-sensitive nature of some of the coloured inks used, especially the blue, purple, green and yellow. The inks were applied with a pen and brush on a sheet of heavy weight white wove paper. Vigorous pen marks in black Indian ink contrast areas of delicate ink washes in muted tones and occasionally scratch into the paper surface. The space is brimming with the everyday objects to be found in an artist's studio, including bottles, paintbrushes, cans, books, chairs, pliers, crumpled paper and cups. The multiple viewpoints and tilted planes show how Guttuso had assimilated the innovations of Cézanne and cubism, and reworked them into his own brand of realism.

The artist gave this work as a present to the Kahnweilers in 1962, inscribing it 'To Ely and Gustav with Guttuso's affection, Velate 62'. Velate is a small town in the countryside near Lake Maggiore where, from 1953, Guttuso spent long periods in the summer. His wife Mimise had inherited a villa there, where he kept a large studio and entertained friends, artists and intellectuals. Among Guttuso's guests were the poet Eugenio Montale, the actor Gary Cooper, the film-maker John Huston, the British painter Graham Sutherland, the sculptor Giacomo Manzù and Daniel-Henry Kahnweiler.[16] The inscription indicates that Gustav and Elly were among those who visited him there in 1962. GB

20
Renato Guttuso
Still Life in the Studio 1962
Natura morta nello studio

Pen and ink and ink wash on
paper
32 × 34.5
Inscribed 'a Ely | a Gustav | con
l'affetto | di | Guttuso | Velate 62'
b.r. in black ink
Bequeathed by Elly Kahnweiler
1991 to form part of the gift of
Gustav and Elly Kahnweiler and
accessioned 1994
T06831

Provenance
Gift of the artist to Gustav and
Elly Kahnweiler 1962

Paul Klee 1879–1940

Paul Klee worked on a small scale, creating microcosmic worlds in drawings, water-colours and oils. Frequently creations of the imagination and often childlike in their apparent simplicity and directness, his pictures were nonetheless rooted in acute observation of the natural world, human behaviour and an appreciation of the small, unremarked incidents of everyday life. Many of his works on paper are care-fully mounted on different coloured pieces of cardboard, with their titles and date of execution added to the bottom of the sheet. During the early Bauhaus years in Weimar, fellow painter and teacher Lyonel Feininger and his wife Julia were neigh-bours of the Klees. They later recollected Klee at work: 'for hours he would sit quietly in a corner smoking, apparently not occupied at all – but full of inner watching. Then he would rise and quietly with unerring surety he would add a touch of colour here, draw a line or spread a tone there, thus attaining his vision with infallible logic in an almost sub-conscious way'.[1]

Klee's first contact with Daniel-Henry Kahnweiler's gallery occurred in 1912. He visited the gallery during his second trip to Paris, where he saw paintings by Vlaminck, Derain and Picasso. He was able to see works by Braque, also represented by Kahnweiler, and Picasso in the private collection of Wilhelm Uhde, a major German collector of cubist painting who had been living in Paris since 1904. Klee continued to see works by these artists in the collection of Hermann Rupf, a close friend of Daniel-Henry Kahnweiler. After the war Klee lived in Munich. Between 1919 and 1920, however, he travelled frequently to Bern to visit Rupf and while there he got to know Daniel-Henry Kahnweiler, who at that time was living in the city. The two rapidly established a friendship.[2] Years later, in October 1933, when Klee left Düsseldorf to return to Bern after mounting attacks by the National Socialists on his art and on modern art in general, Rupf persuaded Kahnweiler to represent Klee. As Kahnweiler usually only showed those artists he had discovered, this demon-strated an unusual departure. In June 1934 Klee became the first German-speaking artist to exhibit at the Galerie Simon, an exhibition that met with very little response; the only buyer was Christian Zervos, editor of the magazine *Cahiers d'Art*.[3]

Klee was represented during the 1920s first by Hans Goltz, from 1919 until 1925, then by Kahnweiler's business associate Alfred Flechtheim from 1925 onwards. In 1929 Flechtheim celebrated the artist's fiftieth birthday with an exhibition in his Berlin gallery. *The Protector* 1926 (no.21) is illustrated on the first page of the accompanying catalogue, and it is possible that Gustav Kahnweiler acquired the work from this show. Gustav was close to Hermann Rupf, who was a member of a collecting circle known as the Paul Klee Society, formed in 1925 by the collector Otto Ralfs. This group bought works directly from Klee at a substantial discount. When Klee was forced into exile in 1933, the Society's purchases provided him with important financial support. *Historical Site* 1927 (no.22) belonged to Rupf after 1933 and it is possible that Gustav Kahnweiler acquired it from him. In the 1950s and 1960s Gustav bought and sold Klees which he is thought to have obtained through his contacts with members of the Society. SR

21
Paul Klee
The Protector 1926
Der Beschützer

Pen and ink on paper on board
30 × 48.7
Inscribed '26 212 JCA' and 'Kl'
t.r. in pencil, '1926.u.8' b.l.,
and 'der Beschützer' b.r.
Presented by Gustav and
Elly Kahnweiler 1974 and
accessioned 1994
T06794

Provenance
... ; Gustav and Elly Kahnweiler
by January 1960 when lent to
the Tate Gallery

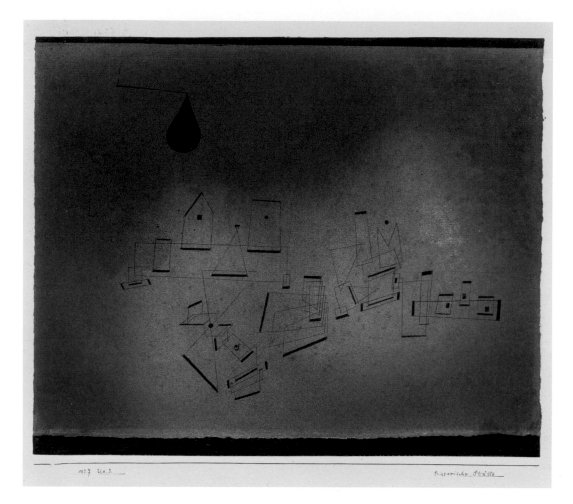

22
Paul Klee
Historical Site 1927
Historische Stätte

Watercolour and ink on paper on
card on board
35.5 × 48.7
Inscribed '1927 Ue.3.' b.l. in
black ink, 'historische Stätte'
b.r. in black ink, and 'Klee'
b.l. in black ink
Bequeathed by Elly Kahnweiler
1991 to form part of the gift of
Gustav and Elly Kahnweiler and
accessioned 1994
T06797

Provenance
… ; Hermann Rupf, Bern, after
1933; … ; Gustav and Elly
Kahnweiler by January 1958
when lent to the Tate Gallery

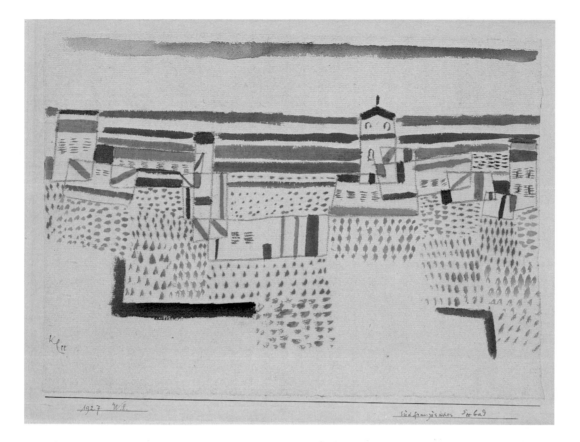

23
Paul Klee
**Seaside Resort in the South
of France** 1927
Südfranzösisches Seebad

Pencil, crayon and watercolour on
paper on board
32.4 × 48.8
Inscribed 'Klee' and '1927 W.8'
b.l. in black ink, and
'Südfranzösisches Seebad'
b.r. in black ink
Presented by Gustav and
Elly Kahnweiler 1974 and
accessioned 1994
T06795

Provenance
... ; Gustav and Elly Kahnweiler
by January 1957 when lent to
the Tate Gallery

Burdened Children 1930

Klee's appointment in 1921 as a teacher at the Bauhaus in Weimar introduced a new phase in his art. He began to formulate a more theoretical approach, giving his art a rational basis as a counterweight to the power of intuition. His pedagogical notebooks formed the basis of lectures and of several essays he wrote in the early 1920s, in which he explored the fundamental components of his creative process: line, tone-value and colour. However, Klee still believed that theory was but a means to an end or, as he put it, 'a device for achieving clarity'.

Burdened Children illustrates the manner in which Klee elaborated elements of these fundamental principles. 'I begin where all pictorial form begins: with a point that sets itself in motion.'[4] This drawing, as many others, demonstrates the movement from a point to a line, which in turn creates planar forms. It consists of an almost unbroken line that forms a series of round-cornered, interlocking boxes. Klee then added stick legs and eyes to give the shapes a human character. It was unusual for Klee to have given the two figures such heavy outlines, a feature chiefly associated with his work in the later 1930s. However, the heavy black might have been one reason for giving the drawing its title. Klee clearly found something unusual in this composition, because he made five variants in different media. In one version, also called *Burdened Children* 1930 (coloured crayon on paper, on card, Kunstsammlung Nordrhein-Westfalen) he gave the figures only one set of eyes, which relates the composition to an earlier picture of a similar subject, the more geometrically conceived single figure of *The Burdened One* 1929 (oil and chalk on jute cloth, mounted on wood, Kunstsammlung Nordrhein-Westfalen). The closest in compositional elements to the Tate work is *Twins* 1930 (oil on canvas, present location unknown), although Klee filled the inner planes of the figures with a combination of shading, hatching and dots. Klee gave new titles to two other pictures, *Twins* 1930 (charcoal on paper, private collection) and *Siblings* 1930 (oil and watercolour on canvas, private collection), adding delicate shading to the interlocking boxes and, in each work, replacing the mouth with a heart. These changes have the effect of lifting the burden of anxiety from the inextricably twinned figures and creating instead the warmth of companionship. SR

24
Paul Klee
Burdened Children 1930
Belastete Kinder

Pencil, crayon and pen and ink on paper on board
65 × 45.8
Inscribed 'Klee' b.l. in brown ink, '1930.v.g. belastete Kinder' b.c. in brown ink
Bequeathed by Elly Kahnweiler 1991 to form part of the gift of Gustav and Elly Kahnweiler and accessioned 1994
T06796

Provenance
... ; Gustav and Elly Kahnweiler by January 1958 when lent to the Tate Gallery

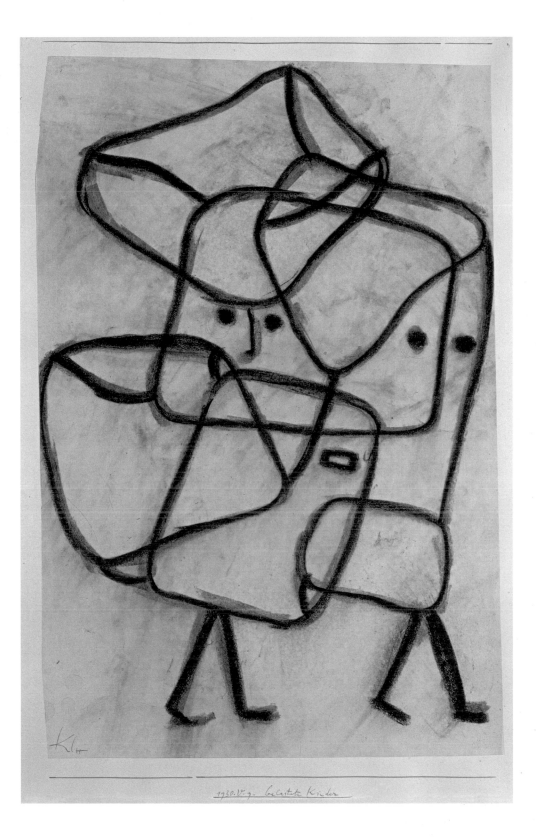

1930.V.9. belastete Kinder

Marie Laurencin 1885–1956

Marie Laurencin was a well-known figure in Parisian avant-garde circles as early as the 1900s and was associated with the artists and intellectuals of the Bateau Lavoir, a decaying Montmartre building made of wood and glass which housed Picasso's and Gris's studios among others. A regular exhibitor at the Paris Salons in 1911, she took part in the Salon des Indépendants, where her work was shown in a gallery along-side paintings by Robert Delaunay, Albert Gleizes, Henri Le Fauconnier, Fernand Léger and Jean Metzinger. This room has been described by art historian Christopher Green as heralding 'the second phase of cubism'.[1] Although Laurencin did not adopt Picasso's or Braque's revolutionary style, she introduced muted earthy colours and geometrical volumes into her paintings of the early 1910s in response to their work. This may explain why her former lover Guillaume Apollinaire included her in his book *Les Peintres cubistes* in 1913. In the same year Laurencin was offered her first contract jointly by two major international art dealers, Paul Rosenberg in Paris and Alfred Flechtheim in Düsseldorf. Laurencin knew Daniel-Henry Kahnweiler but was never represented by him.

Having married the German artist Otto von Wätjen on 22 July 1914, she became a German citizen and had to leave France with him at the outbreak of the First World War. They fled to Spain, where they lived in Madrid and Barcelona. They left Spain in November 1919 and travelled to Genoa, Milan and Zürich before settling in von Wätjen's native city, Düsseldorf, at the beginning of 1920. In the spring of that year von Wätjen exhibited his work at the Galerie Flechtheim in that city. The following spring Laurencin left her husband and returned to Paris on her own, where she had her first post-war exhibition, showing twenty-five works at the Galerie Paul Rosenberg. Rosenberg's show relaunched Laurencin's career after her exile, and her reputation as an artist spread throughout Europe and to the United States. In the same year the poet Roger Allard wrote a critical study of Laurencin, *Marie Laurencin et son oeuvre*, in which he described her as 'undoubtedly the most celebrated woman artist of today'.[2] In 1922 Gallimard published *L'Eventail de Marie Laurencin* (The Fan of Marie Laurencin), a small deluxe edition with ten Laurencin engravings and contri-butions by André Breton, Max Jacob, André Salmon and Allard among others, which

has been described as a 'poetic homage' to her.[3] In 1930 she was photographed for the magazine *Vu* with the writer Colette and the poet-aristocrat Anna de Noailles as 'one of the three most famous women in France'.[4]

Laurencin's critical reception has varied considerably over the years. Until the 1930s she was fêted as a member of avant-garde circles and of fashionable Parisian society. At this time her work and artistic identity were seen as exquisitely feminine. In 1917 the *New York Post* described Laurencin as 'endowed with charm and distinction, with a felicitous light touch, with grace and gayety [sic] of spirit ... Her art is feminine, willful yet just, with the justness of an artist of exceptional sensitiveness, sometimes a little sardonic, often a little slight, tantalizing and alluring.'[5] In his 1921 book, Allard wrote of her art as feminine in a coquettish, narcissistic way: 'Her art is selfish and charming and ... compares everything to itself. She has no other subject than herself, no other curiosity than to know herself better. Having no fondness except for any objects or forms of nature that resemble her ... Marie Laurencin only questions nature and life in order to find more urgent and unforeseen reasons to love herself.'[6]

From the end of the 1930s her work was all but ignored for many decades until a resurgence of interest in the 1980s. A catalogue raisonné of her engraved work published in 1981 was followed in 1983 by the inauguration of the Marie Laurencin Museum in Nagano-Ken, Japan, and by a catalogue raisonné of her paintings in 1986. Moreover, her work and sexual identity were rediscovered by feminist art historians, who propounded alternative readings of her work. Eschewing the discussions of grace and femininity of earlier theorists, some of the latest Laurencin studies underline the importance of her sexual identity within her art. Indeed, she has been credited by one commentator for creating 'a visual language of female creativity and lesbian desire in early twentieth-century Paris'.[7] In a study of a number of early Laurencin self-portraits, art historian Elizabeth Kahn has described her as 'a young woman in the process of negotiating her way out of conventional femininities', adding that 'she seemed to be searching for a unique identity that could resist the historic control of the male viewer'.[8] GB

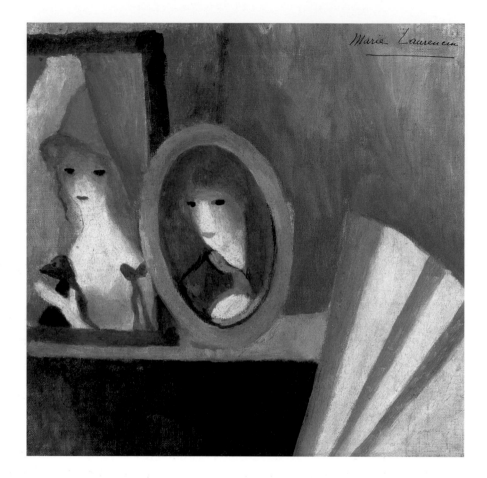

The Fan *c.*1919

The Fan is painted in Laurencin's typically restrained palette of blue, rose and grey. It depicts two women staring at the viewer from two frames on a table. It is likely that the woman in the oval frame is the artist herself. The identification of the other, however, is uncertain. She may simply be a model holding Laurencin's little black dog Coco, or she may represent the idea of a loved one the artist was missing in her forced Spanish exile, possibly the dress-maker Nicole Groult. Laurencin had met Groult in 1911 and they are said to have been lovers at some point in the following years. The image is intriguingly ambiguous. The frames may represent mirrors or pictures within a picture, while the fan, which was one of Laurencin's favourite accessories and a symbol of vanity, may indicate the presence of another person in the room.

 The Fan was Elly Kahnweiler's personal property. It is thought to have been Gustav's wedding present to her[9] and it is likely that it came from Alfred Flechtheim's galleries. On the back of the work was a label from the Düsseldorf branch of the Galerie Flechtheim stamped with a stock number.[10] GB

25
Marie Laurencin
The Fan *c.*1919
L'Eventail

Oil on canvas
30.5 × 30
Inscribed 'Marie Laurencin'
t.r. in black paint
Bequeathed by Elly Kahnweiler
1991 and accessioned 1994
T06805

Provenance
... ; Elly Kahnweiler by December
1951 when lent to the Tate Gallery

Henri Laurens 1885–1954

'You asked me in an earlier letter what sculpture Laurens was making', Braque wrote in 1919 to Daniel-Henry Kahnweiler, then cooling his heels in Bern while waiting to return to Paris after the ending of the war. 'It has to be said that to some extent he was my pupil, that is, he [did] lots of drawings on paper that resembled mine, some of them at least. In terms of sculpture he works with lots of spirit and feeling. But I feel that painting still appears a little bit too much in most of his things. I think he can produce something from his efforts.'[1]

Although this was not the most generous of appraisals, Braque certainly played an important role in Laurens's evolution as a sculptor. The wives of the two artists were good friends and from 1911 to the early 1920s the couples lived close to each other in Montmartre. Although Laurens had been aware of the cubist works of Léger and the sculptor Alexander Archipenko from the summer of 1910, it was only when Braque patiently explained to him in detail his stylistic evolution from a Cézannesque geometricisation of forms to an imagery of faceted planes and signs that, according to his wife, Laurens first began to glimpse the implications of the cubist revolution. It was not until 1915, however – three years after Braque's invention of 'papiers collés' and Picasso's first constructed sculptures – that Laurens began to make cubist sculptures.

In his first cubist works, which were typically of the human figure, Laurens employed cones, blocks and cylinders, echoing the principles of early cubism which in turn was indebted to the precepts of the nineteenth-century French painter Cézanne. However, he soon sought a three-dimensional equivalent for the interpenetrating planes and mingling of viewpoints found in analytical cubist still lifes of c.1910–12. He became preoccupied with using geometric shapes that were not imitative of reality but possessed what he described as a life of their own. He was particularly concerned to use forms that he felt did not change their character under different lighting conditions (and would therefore avoid evoking comparisons with everyday reality). In 1919 he summed up his credo: 'I compose my forms and rhyme them through equivalents and oppositions, using directions and dimensions that are able to offer an intensity of representation from the point

26
Henri Laurens
Seated Woman *c.*1926–30
Femme assise

Gouache on paper
30.1 × 22.7
Inscribed 'HL' b.r. in pencil
Bequeathed by Elly Kahnweiler
1991 to form part of the gift
of Gustav and Elly Kahnweiler
and accessioned 1994
T06832

Provenance
Daniel-Henry Kahnweiler (Galerie
Simon, Paris, stock number 9421);
with London Gallery, London,
1937; acquired by Gustav
Kahnweiler 1947 ('placed on
deposit in 1937 in England, and
formally acquired in 1947 by M.
Gustav Kahnweiler', letter to Tate
from Galerie Louise Leiris, Paris,
26 May 2000)

of view of the work's own life – in other words, to create and not to imitate or interpret.'[2]

On his arrival in Paris in late February 1920 Kahnweiler lost no time in seeking out Laurens, who accepted an offer of a contract in April of that year. Inexplicably, however, Kahnweiler did little to promote Laurens's work. Laurens illustrated a text by the playwright Raymond Radiguet for the Editions Galerie Simon, and showed works in a mixed exhibition. But he never had a solo exhibition, and this may have been a reason why, in the wake of Braque's defection, he, too, left Kahnweiler.

By this point Kahnweiler had acquired a significant amount of Laurens's cubist production, and this stockpiling of work may have contributed to the lack of critical attention paid to Laurens during his lifetime. Shortly after Laurens's death, however, Kahnweiler organised an important retrospective of the artist, whom he described in his memoirs as 'admirable for his optimism, modesty and kindness'.[3] JM

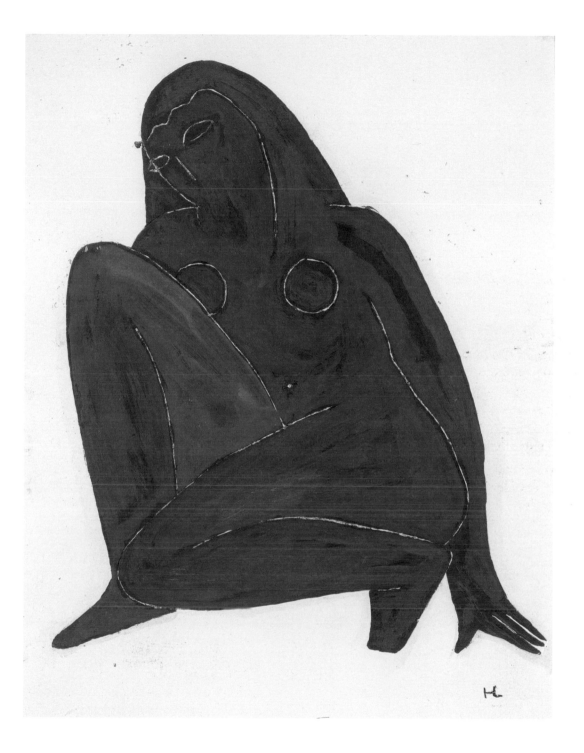

Bottle and Glass 1917

Bottle and Glass is one of a series of austere collages made by Laurens between 1916 and 1917. The series was initiated with at least two collages known as *Bottle and Newspaper*. In these can be traced the beginnings of the split view of the central bottle found in *Bottle and Glass*, with a left profile providing the straight neck and part of a curve describing the body of the bottle, and a right profile consisting of angular projections. A small circle, representing the bottle's mouth, provided a linchpin for both these profiles. The theme was then developed in a further ten collages in 1917, each made with the same restricted range of materials: a white ground, pieces of brown paper of various shades and textures, occasionally some black paper or newsprint, and black and white chalk. Through the series Laurens developed the features seen in stripped-down form in *Bottle and Glass*: an angular background, which can be read as an abstracted or schematised table or architectural setting; a shaded line representing the left-hand side of the bottle; and a white-chalk drawing of a glass, mapped with a few straight and curving lines as if seen from the top, side and behind.

In a number of works in the series the bottle is identified as one of Beaune wine. This name allowed for allusions to the word 'beau' (beautiful), in the same way as Laurens, and before him Picasso and Braque, had repeatedly played on shortened forms of the word 'journal' (newspaper), including 'jou' (play/enjoy) and 'jour'(day). In *Bottle and Glass*, one of the most austere of the series, Laurens used as a substitute label for the bottle a newspaper advertisement for a periodical, *La Médécine Végétale*, which has the strap line 'Everyone his own doctor'. The reason for this choice is unknown but it may have been a joke about the medicinal qualities of wine. Laurens used punning printed matter in two other works of the series: in one instance to complete half of the letters A and L in the otherwise handwritten 'JOURNAL' and, in another, to label a bottle with the number '837' and the words 'L'Etang-la-Ville', the name of a small village where had stayed in 1916 and where he was to have a second home. JM

27
Henri Laurens
Bottle and Glass 1917
Bouteille et verre

Collage, graphite pencil, oil paint, black and white chalk on millboard
38.8 × 29.1
Inscribed 'LAURENS '17' b.l. in black watercolour
Presented by Gustav and Elly Kahnweiler 1974 and accessioned 1994
T06806

Provenance
Daniel-Henry Kahnweiler (Galerie Simon, Paris, stock number 11206); with London Gallery, London, 1937 (label on reverse); acquired by Gustav Kahnweiler 1947 ('placed on deposit in 1937 in England, and formally acquired in 1947 by M. Gustav Kahnweiler', letter to Tate from Galerie Louise Leiris, Paris, 26 May 2000)

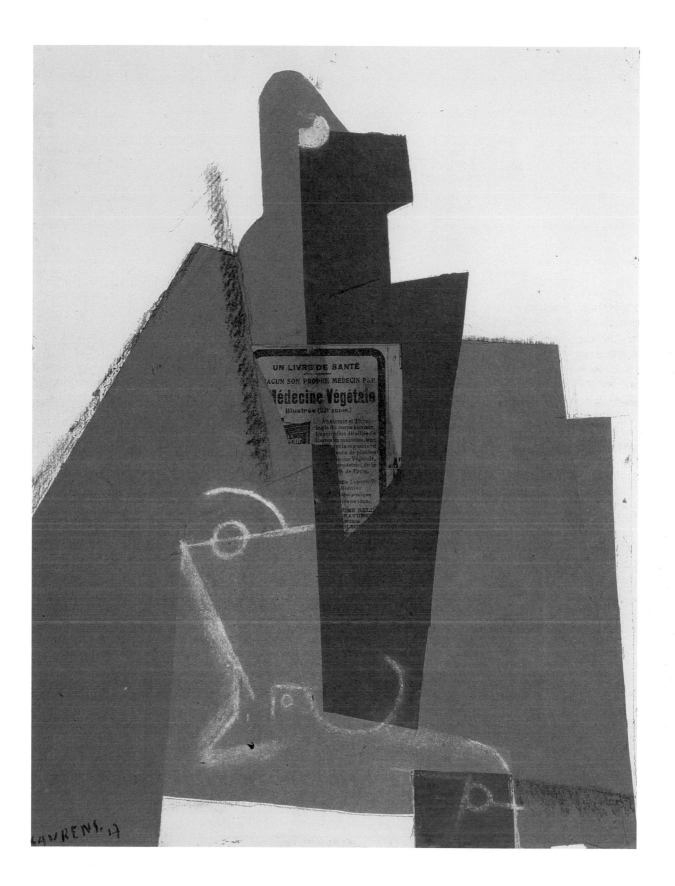

Head of a Young Girl 1920, **Head of a Boxer** 1920

Made when Laurens had come under con-tract to Kahnweiler, *Head of a Young Girl* and *Head of a Boxer* reflect a move away from the more austere and abstract works of the war years. Along with his friends Braque and Gris, Laurens explored in 1920 a type of cubism that retained key ele-ments of the style – notably multiple view-points – but permitted freer allusions to reality. The critic Louis Vauxcelles, who was hostile to cubism, wrote of the shift to greater naturalism in the work of post-war cubist artists: 'One reads their works; they are still more allusions to the object than transcriptions. But one notices that they have stripped themselves of their aloof har-diness, and that ... they have decided to give sensibility as large a part as intelligence.'[4] To what extent this greater legibility represented a betrayal of the earlier purist stance of cubism was a question much debated in the press of the period.

In a statement published in 1919 Laurens had summed up his aim as 'to create and not to imitate or interpret', claiming for himself the freedom to take his medium, rather than nature, as his starting point. But the humour, surface stylisations and sensuality of his works of the early 1920s suggest a desire to 'humanise' cubism, possibly in response, at some level, to the negative criticism of cubism in France in these years of the 'return to order' move-ment and to the commercial failure of his more rigorous works.

Laurens lived in extremely reduced circumstances in these years ('One can imagine nothing more wretched', wrote Kahnweiler in his memoirs).[5] He used terra-cotta frequently in this period simply because, according to his dealer, he could not afford bronze. With its humorously crooked nose, the *Head of a Boxer* relief was first carved in stone (with a decorative dado rail in the background), and then cast in an edition of eight painted terracotta examples.[6] Laurens used the face of the boxer again in a three-dimensional stone sculpture of the same date (Staatliche Kunstsammlungen Kassel, Neue Galerie). The limestone *Head of a Young Girl* was also first made in terracotta.[7] JM

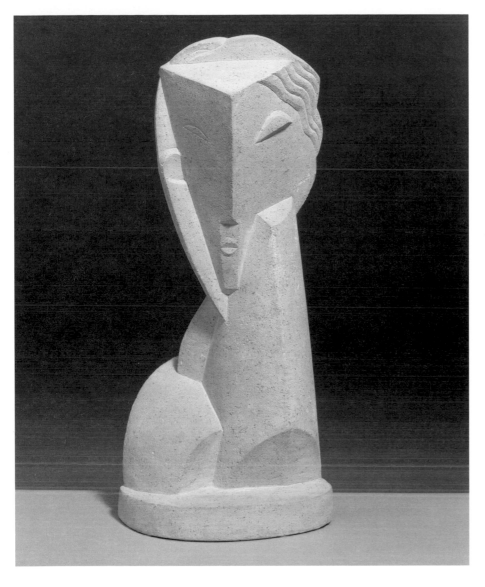

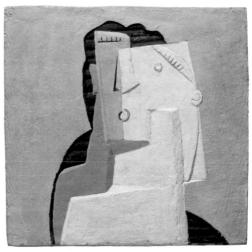

29
Henri Laurens
Head of a Boxer 1920, cast 1921
Tête de boxeur

Painted terracotta
24.2 × 23.8 × 2.5
Incised on back 'H.L' t.r. and
'No.8' b.r.
Bequeathed by Elly Kahnweiler
1991 to form part of the gift of
Gustav and Elly Kahnweiler and
accessioned 1994
T06833

Provenance
Daniel-Henry Kahnweiler (Galerie
Simon, Paris, stock number 6248);
Gustav Kahnweiler ('We have
not managed to determine a date
of sale. Perhaps it was also a
present made by Daniel-Henry
Kahnweiler to his brother', letter
from Galerie Louise Leiris, Paris,
to Tate, dated 26 May 2000)

28
Henri Laurens
Head of a Young Girl 1920
Tête de jeune fillette

Limestone
39.3 × 17.4 × 12.5
Incised 'H.L' on centre of back
and edge of base
Presented by Gustav and
Elly Kahnweiler 1974 and
accessioned 1994
T06807

Provenance
Daniel-Henry Kahnweiler (Galerie
Louise Leiris, Paris, stock number
6242); Gustav Kahnweiler ('I have
not identified the date of acquisi-
tion by M. Gustav Kahnweiler.
It was perhaps a present made
around 1958', letter from Galerie
Louise Leiris to Tate, 26 May 2000)

30
Fernand Léger
Trees 1923
Arbres

Pencil on paper
32.2 × 24.2
Inscribed 'F.L 23' b.r. in pencil
Bequeathed by Elly Kahnweiler
1991 to form part of the gift
of Gustav and Elly Kahnweiler
and accessioned 1994
T06801

Provenance
Daniel-Henry Kahnweiler (Galerie
Simon, Paris, stock number 7510);
purchased by Gustav and Elly
Kahnweiler 1947 (letter from the
Galerie Louise Leiris, Paris, to
Tate, 26 May 2000)

Fernand Léger 1881–1955

Daniel-Henry Kahnweiler started to frequent Fernand Léger's studio in 1911, after he had seen the latter's canvas *Nudes in a Landscape*[1] at the Salon des Indépendants. In 1912 he began to sell Léger's paintings and the following year offered him a contract, gaining exclusive rights to his work for three years.[2] Léger's work of the time was very different from that of Picasso and Braque, but Kahnweiler always referred to it as cubist although, he acknowledged, 'in different ways from Braque and Picasso'. 'Léger simplifies all forms, he makes them more coarse. He reduces them to figures that are very close to essential forms – the cube, the sphere, the cylinder – showing a particular predilection for the cylinder. He always takes care to safeguard the integrity of the form and never goes so far as destroying it.'[3]

When Kahnweiler returned to France in 1920, Léger was selling his work principally to Kahnweiler's rival Léonce Rosenberg, and it was only in 1921 that Rosenberg, while retaining the rights over large-scale paintings, agreed to share the artist's production with Kahnweiler. The same year Léger made six woodcuts to illustrate André Malraux's book *Lunes en papier*, published by the Galerie Simon. In 1925 Daniel-Henry started sending Léger's work to the Galerie Flechtheim und Kahnweiler in Frankfurt, then directed by his brother Gustav, but it was not until 1928 that Léger had an exhibition with Flechtheim, in the Berlin branch of the Flechtheim galleries.

Contact between Kahnweiler and Léger became sporadic after the Second World War. In 1954 Kahnweiler commissioned him to decorate the dining room of his country house; the artist died soon after completing it. Kahnweiler was not only saddened by Léger's death but also angered at the French nation's failure to commission a major work from him. A clue to the strength of the personal relationship between the artist and his dealer can be found in the words that Léger supposedly said to his wife Nadia shortly before his death: 'Don't listen to anyone else, and don't work with anyone other than Monsieur Kahnweiler. I have complete faith in him. He is the one who discovered me, who encouraged me, placed me under my first contract, saved me from starving ... It's thanks to Kahnweiler that I'm Fernand Léger.'[4] GB

Mechanical Elements 1926

The representation of modern life was a major theme for Léger. He returned to the subject of 'mechanical elements' many times in the late 1910s and 1920s. In a letter of 1919 to Daniel-Henry Kahnweiler he wrote, 'I have used mechanical elements a lot in my pictures these last two years; my present method is adapting itself to this, and I find in it an element of variety and intensity. The modern way of life is full of such elements for us; we must know how to use them.'[5] These works are still lifes in which mechanical elements take the place of the everyday objects traditionally depicted within this genre. They are not, however, drawings of machines themselves but a representation of machines as geometrical forms.

Léger's interest in the mechanical was wide ranging and he did not limit himself to expounding his ideas through his art. In 1923–4, for example, he made *Ballet mécanique*, a film first shown in Paris in November 1924, which employed 'figures, fragments of figures, mechanical fragments, metallic (fragments), manufactured objects, enlargement with the minimum of perspective'. This has been described by art historian Christopher Green as 'an experiment in the controlled creation of movement ... using the photographic image, mobile or static, as the basic unit in a series of measured rhythmic sequences.'[6] The mechanical elements in the film were closely related to Léger's exploration of the subject in his paintings.

In the mid-1920s Léger was in close contact with Amédée Ozenfant and Charles-Edouard Jeanneret (better known as Le Corbusier), who were the chief advocates of purism. Although Léger's work from that period is seen as reflecting some qualities of the purist style, in particular, clarity, starkness, stillness and frontality, he commented: 'Purism did not appeal to me. Too thin for me, that closed-in world. But it had to be done all the same; someone had to go to the extreme.'[7] This work combines Léger's signature mechanical forms with a calm and restraint that are absent from previous *Mechanical Elements* compositions and are consonant with the ideas of Ozenfant and Jeanneret.

A drawing for this gouache, in the collection of the Musée Fernand Léger in Biot, is inscribed 'F.L. 32'. The artist originally gave the drawing to Raymond Abner, who attended his academy in the 1950s, and it is likely that he signed and dated the work erroneously when dedicating it to Abner.

GB

31
Fernand Léger
Mechanical Elements 1926
Eléments mécaniques

Watercolour, pencil and
pen and ink on paper
24.2 × 30.3
Inscribed 'F.L. 26' b.r. in pencil
Presented by Gustav and
Elly Kahnweiler 1974 and
accessioned 1994
T06798

Provenance
Daniel-Henry Kahnweiler (Galerie
Simon, Paris, stock number 9288);
purchased by Gustav and Elly
Kahnweiler 1947 (letter from the
Galerie Louise Leiris, Paris,
to Tate, 26 May 2000)

32
Fernand Léger
ABC 1927

Gouache on paper
19.4 × 27.8
Inscribed 'F.L. 27' b.r. in black ink
Presented by Gustav and
Elly Kahnweiler 1974 and
accessioned 1994
T06799

Provenance
Daniel-Henry Kahnweiler (Galerie
Simon, Paris, stock number
10020); purchased by Gustav and
Elly Kahnweiler 1947 (letter from
the Galerie Louise Leiris, Paris,
to Tate, 26 May 2000)

33
Fernand Léger
Three Bottles 1954
Les Trois Bouteilles

Oil on canvas
33 × 46
Inscribed '54 | F. LEGER'
b.r. in black paint
Presented by Gustav and
Elly Kahnweiler 1974 and
accessioned 1994
T06800

Provenance
Galerie Louise Leiris, Paris (stock
number 06002); acquired by
Gustav and Elly Kahnweiler by
January 1957 when lent to the
Tate Gallery

André Masson 1896–1987

Of the 'second generation' artists that joined Galerie Simon in the 1920s, André Masson was perhaps the closest to Daniel-Henry Kahnweiler. At crucial moments in the artist's career Kahnweiler provided invaluable moral and financial support, and there was a longstanding and genuine friendship between the two men.

Kahnweiler first visited Masson's studio at 45 rue Blomet, close to that of Miró and, another gallery artist, Elie Lascaux, in 1922. Masson's circle of friends included writers and poets (it had been the celebrated poet and close friend of Picasso, Max Jacob, who recommended the young artist to Kahnweiler). Masson was then struggling to support his family by odd jobs, painting when he could and still trying to find his way as an artist. He later commented about Kahnweiler's offer of a contract in late 1922: 'You can imagine what it meant for an artist who could only paint on the run; I was half-crazed. With Kahnweiler, I had the stability needed to begin painting seriously, really seriously, with the opportunity of thinking only about painting.'[1] Masson showed works at the Galerie Simon in May 1923 alongside Braque, Derain, Gris, Lascaux, Laurens, Manolo, Picasso, Togores and Vlaminck. In February 1924 he had a solo exhibition that brought him to the attention of André Breton and the nascent surrealist group of which Masson was to become a central figure.

Kahnweiler was remarkably open to surrealism in this early period. While he may have been attracted to Masson's work because of its indebtedness to cubism, he nonetheless saw Masson's preoccupations with nature and with spontaneity – already hinted at in works of the early 1920s – as very much a positive development of cubism and not a reaction against it. Kahnweiler was later to be critical of the works of such surrealist artists as Ernst and Dalí but he always supported and admired Masson, even when the latter was most closely associated with the surrealist group.

As their correspondence shows, Kahnweiler offered Masson patient encouragement and passionate intellectual support over the years. Masson became a friend of the family and regularly attended Kahnweiler's Sunday lunchtime gatherings (for a period his baby spent more time with the Kahnweilers than with him as the conditions in rue Blomet were so wretched[2]). When Masson succumbed to the offers from

the dealer Paul Rosenberg of more money in 1928, Kahnweiler was deeply wounded, writing, 'I had tried, for you more than anyone else, to be more than a dealer.'[3] Masson later apologised for his lack of loyalty and rejoined Galerie Simon in 1933.

Through the Depression years Kahnweiler continued to support Masson financially, though his works hardly sold. He attempted to promote Masson through a contractual relationship with the dealer Wildenstein (until the latter pulled out because of lack of sales), and then through the Mayor Gallery in London and the Curt Valentin Gallery in New York. With the onset of war Masson – who had been traumatised by his experiences in the trenches during the First World War – escaped to America. He returned in 1945 and once again Kahnweiler offered him regular shows. In the 1950s he strongly supported the artist's new absorption with impressionism and Chinese calligraphy.

It seems likely that Gustav Kahnweiler met Masson through his brother, quite possibly in the early 1920s, as a number of the works in his collection date from this period. Although there is no evidence of a particularly close relationship, Gustav was certainly in touch with Masson in the post-war years.[4] Anxious to please Masson, Gustav wrote to the Tate in 1955 asking if *Riez* (no.38), then on loan to the gallery, might be publicly displayed when the artist was due to be in London for the opening of his exhibition at the Leicester Galleries.[5] Interestingly, the range of Massons in Gustav's collection reflects his brother's personal collection, which was strong in works of the 1920s and 1950s but contained nothing of the late 1930s or 1940s. This may suggest that many of the works in Gustav's collection were gifts from his brother. JM

34
André Masson
Pedestal Table in the Studio 1922
Le Guéridon dans l'atelier

Oil on canvas
49.8 × 65
Inscribed 'André Masson'
b.l. in black paint
Bequeathed by Elly Kahnweiler
1991 to form part of the gift of
Gustav and Elly Kahnweiler and
accessioned 1994
T06819

Provenance
Acquired from Daniel-Henry
Kahnweiler (Galerie Simon, Paris)
by Gustav Kahnweiler 1923 (letter
from Galerie Louise Leiris, Paris,
to Tate, dated 26 May 2000)

Pedestal Table in the Studio 1922

This painting is typical of Masson's style of the period in which he first met Daniel-Henry Kahnweiler. The placement of the musical instruments (a mandolin and the curving body of what appears to a guitar) on a tabletop, and the rhyming of straight and curved lines, allude unmistakably to the pre-war cubist paintings of Picasso and Braque. Although the neck of the mandolin appears as if seen from more than one perspective, there is no real attempt to employ the facets, planes or abstruse signs of cubist form language. Instead, the painting seems largely realist in conception, with overt references to traditional still-life painting in the presence of the flowers, fruit and dead bird. In this sense, the painting could be seen as reflecting to some extent the themes – if not the values – of the post-war 'return to order' movement in France, which advocated qualities of clarity and harmony, and a modern reading of traditional art. But – as Kahnweiler was the first outside Masson's immediate circle to recognise – the unexplained elements, the strange spatial qualities and bleached coloration of his paintings of this period indicate a new and individual approach.

Recalling the works of this period, Georges Limbour – a friend of the artist from the earliest days – stressed the unnatural atmosphere of Masson's paintings. He described the painter as a 'magician' who concealed secrets and mystery behind everyday appearances. 'Wand in hand, and putting objects back to rest in their forms, André Masson seemed to approach painting along the path of calmness. But this calmness was all appearance. Behind it lurked disquiet and a certain metaphysical passion.' The bleached tones lent his imagery an ethereal quality. Masson, Limbour wrote, 'used a great deal of white, broken by a variety of reflections, the emotional substance of his dreaming. His early still-lifes were touched with those bewitching whites, and every object had a disturbing and somewhat nocturnal appearance: they seemed to be wearing a sort of white mask'.[6]

Behind the mask were indeed not only dreams – suggested perhaps by the spherical cloud forms in the background – but also darker emotions. If the flowers and dead bird could be seen as evoking life and death in somewhat conventional terms, the red pomegranate halves expressed an altogether more bloody and violent vision. The fruit's seeds can be said to symbolise the force of life and regeneration, but the red interior also evokes viscera. Later Masson was to acknowledge that the pomegranate – the French word for which, 'grenade', also means grenade or bomb[7] – evoked for him the memory of the blown-open skull of a soldier in the battlefields of Champagne. His experience of serving in the trenches for three years in the First World War, and of being left for dead in a battle, had scarred him profoundly both physically and mentally, and surfaced more directly in the violent and carnal imagery of some of his later work. JM

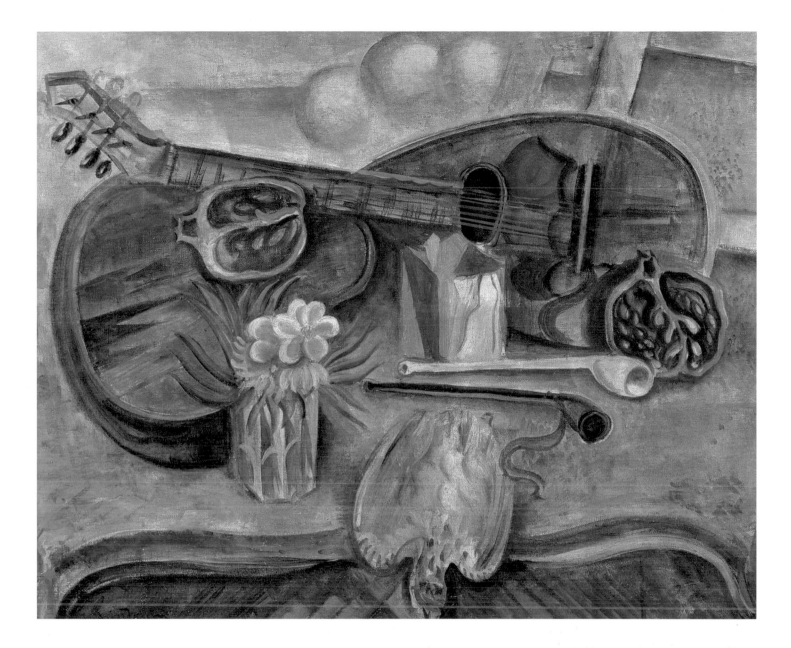

35
André Masson
Guitar and Profile *c*.1923–4
Guitare et profil

Pastel on paper
63.4 × 43.4
Inscribed 'André Masson'
b.r. in brown pastel
Bequeathed by Elly Kahnweiler
1991 to form part of the gift of
Gustav and Elly Kahnweiler and
accessioned 1994
T06820

Provenance
Daniel-Henry Kahnweiler (Galerie
Simon, Paris); Gustav and Elly
Kahnweiler by January 1967 (list
of works deposited at the Tate
Gallery, as *Nature morte profile*,
pastel 1924; listed as *Guitar and
Head* 1925, 18 June 1980)

36
André Masson
Sirens 1947
Les Sirènes

Ink on paper
49 × 63.5
Inscribed 'Les Sirènes | 1967'
in black crayon t.r. of reverse
Bequeathed by Elly Kahnweiler
1991 to form part of the gift of
Gustav and Elly Kahnweiler and
accessioned 1994
T06821

Provenance
... ; Gustav and Elly Kahnweiler
by January 1967 if the work is
the one described as *Main* 1965,
in list of works deposited at the
Tate Gallery

37
André Masson
Kitchen-maids 1962
Les Filles de cuisine

Oil on canvas
50.2 × 61
Inscribed 'André Masson'
b.l. in black paint
Presented by Gustav and
Elly Kahnweiler 1974 and
accessioned 1994
T06818

Provenance
Galerie Louise Leiris, Paris (stock
number 09903); Gustav and Elly
Kahnweiler by January 1963 when
lent to the Tate Gallery, as *Cuisine*

Riez 1953

In 1951 Masson's art took an unexpected turn. In the wake of a trip to Venice he began to paint classical landscapes in a style inspired by J.M.W. Turner, the nineteenth-century British artist who painted many famous scenes of Italy, and by the French impressionist painter Monet. It was an extraordinary step for an artist associated with the avant-garde and known for his visceral, and often violent, vision of the relationship between man and nature.

Masson described the sea change simply as the result of fate deciding to expel him from 'the Hades of art', thereby obliging him to focus on the poetic and happier aspects of painting. Writing in February 1953, from his home in Aix-en-Provence in the South of France, he announced: 'I uncover boundlessness, expansion through light, universal fusion ... A delicate sensualism makes me burst the last chains that still bind me to the "spirit of weightiness". I learn to know the genuinely open and discontinuous form ... From the object, which has become free and no longer oppressive, there emanates a tension more and more diaphanous, prolonged in echoes in every direction, to the very limits of the given surface. The supreme lesson of Turner and the spiritual message of Zen painting have come to me: that which goes counter to the prevailing taste is, for me, the most precious of things.'[8] For an article in the magazine *Verve* he urged young artists to rediscover Monet, declaring his belief that 'contact with the irreplaceable instant'

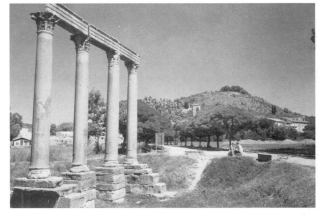

Fig.16
Classical remains at Riez 2001
Photograph
Les Amis du Vieux Riez

would allow them to move beyond the intellectual impasses of the period.[9]

Daniel-Henry Kahnweiler found this shift in Masson's work towards a new romanticism a source of 'consolation' amid the uncertainties of the Cold War ('Is this happy painting a portent of better times, or is it a last ray of sunshine before the destruction of our Europe? Whatever the case, let us not refuse this marvellous exaltation, even if it might be the last').[10] He denied that this change represented a regression, arguing that Masson's discovery of Chinese painting was a fresh element in the artist's plastic language. 'Let anyone look at Masson's recent canvases with an unprejudiced eye and he will see that no detail is imitative but that only the whole, an actual plastic writing, is apparent. He will see that there is no longer anything of the conventional occidental theatre-set with its centre-stage, its wings, its backdrop ... The viewer, within

himself, finds that he is in the middle of the picture; so to speak, within a "space which has become active, growing, ripening, vanishing", to use Masson's own words.'[11]

Painted with loose brushwork and hot colours, *Riez* presents a recognisable view of the historic part of the small Provençal town dubbed Riez la Romaine because of the presence there of classical remains. The canvas shows a well-known landmark, a ruined temple with four six-metre high columns of polished granite with marble capitals and pediment. To the right are faint indications of a medieval village, including a cemetery and tower, which sits at the foot of Mont Ste. Maxime.[12] JM

38
André Masson
Riez 1953

Oil on canvas
65 × 81
Inscribed 'André Masson'
b.l. in yellow paint
Presented by Gustav and
Elly Kahnweiler 1974 and
accessioned 1994
T06817

39
André Masson
Star, Winged Being, Fish 1955
L'Étoile, être ailé, poisson

Oil, sand and glue on canvas
55.1 × 38
Inscribed 'AM | 55' t.r.
in violet paint and sand
Bequeathed by Elly Kahnweiler
1991 to form part of the gift of
Gustav and Elly Kahnweiler and
accessioned 1994
T06822

Provenance
Galerie Louise Leiris, Paris (stock
number 06457); Gustav and Elly
Kahnweiler by January 1960 when
lent to the Tate Gallery

Star, Winged Being, Fish 1955

Masson wrote excitedly to Daniel-Henry Kahnweiler on 15 July 1955 about some new sand paintings he had just begun:

> *I am throwing sandy glue [colle ensablé] onto stretched canvases. I like the result of this research, of this extreme spontaneity ... if in the past I threw sand onto glued surfaces, now it's the glue that I throw onto the support, having only rhythm and the fire of inspiration as my starting point ... it's always the same thing that I want, that is, to reveal movement, the blossoming, or the birth of things (this time it's the act of creation in a pure state).*[13]

Masson had made similar sand paintings in the mid-1920s, a period when he pioneered within the surrealist group the practice of drawing automatically or without conscious control. He made a small number of important sand paintings again in the late 1930s. However, as he wrote in his letter to Kahnweiler, when he returned to this technique in the mid-1950s it was no longer a question of throwing sand on to a glued canvas laid out on the floor but of throwing a mixture of glue and sand onto a canvas in order to create lines or the raised 'islands' of sand.

In *Star, Winged Being, Fish* Masson painted or sprayed adhesive on to the canvas, which he had probably stretched and primed himself. He applied a layer of sand, threw or dribbled on a mixture of sandy glue, and then painted a loose network of lines using the sandy glue mixed with red, blue or yellow paint, possibly squeezed or dribbled from drinking straws or plastic bottles. The area of orange was the result of applying a red sand-paint mixture to an area of yellow sand-paint, while the violet signature was made by mixing red and blue pigment with sand.

Masson said that his earliest sand paintings were inspired by the action of waves on a beach and the undulating motifs created in the sand. Within a network of indeterminate lines, his early sand works typically alluded to human figures and natural motifs such as stars and, above all, fish. Such allusions were repeated in later sand paintings of the mid-1950s. JM

Henry Moore 1898–1986

Although he was already a well-known and highly respected sculptor before the Second World War, Henry Moore's fame increased greatly in the late 1940s, mainly due to the evocative power and popular appeal of his wartime shelter drawings. The first volume of his catalogue raisonné was published in 1944 and he had his first international retrospective in 1946.[1] In 1948 he won the first prize for sculpture at the Venice Biennale. In the 1950s he received more international prizes and several commissions for public work, including sculptures for the Festival of Britain in 1951, the Time-Life building in London in 1952 and the new UNESCO headquarters in Paris in 1956 (installed in 1958).

Although it is unclear when and how they met, it is certain that a lasting friendship united Gustav and Elly Kahnweiler with Henry and Irina Moore by the 1950s. The two couples saw each other regularly and Gustav and Henry wrote to each other often, discussing work as well as leisure activities and personal issues. Moore sent a postcard from Forte dei Marmi, Italy, to the Kahnweilers in 1961, saying: 'We're having the most wonderful weather, so far, and marvellous warm bathing ... The sunshine has demoralised me, and I haven't touched the stone carving I intended to do ... Perhaps it will rain – but I hope not for Mary's and Irina's sakes – they're loving it – so am I. We all three send our love to you both. Henry – Irina and Mary.'[2] In 1970 Moore wrote from Forte dei Marmi, where he had bought a house in 1966: 'We've had six weeks out of my annual 2 months of marble carving here ... I'm working, but not as hard as last year (having no New York exhibitions in the offing!). Am pleased to hear from Mrs. Tinsley [Moore's secretary] that you are getting on allright [sic] Gustav after your operation. We both send our love to you both ... Henry and Irina.'[3] Gustav Kahnweiler was said to be greatly affected by Henry and Irina Moore's deaths in 1986 and 1989 respectively.[4]

Moore was part of an international circle of artists, including Renato Guttuso and Pablo Picasso, who knew each other and were friendly with the Kahnweilers. In 1963 Moore won the prestigious Antonio Feltrinelli Prize, awarded by the Accademia dei Lincei in Rome. Kahnweiler had been told of this by the organisers and was quick to congratulate him from the hotel in Ischia where he and Elly were staying, writing:

'We all – the Guttuso's [*sic*] are just now here with us – join together to celebrate your wonderful success.'[5]

As well as buying Moore's work for himself, Kahnweiler, who in that period spent the first six months of each year travelling and had a large network of international connections, acted as a private dealer for Moore in Britain and especially abroad. Moore's secretary regularly sent him lists and photographs of works available for sale and Kahnweiler negotiated the sale of Moore's sculptures both to private and public collections. Among the latter was the Kunstmuseum Basel, which bought a Moore sculpture through Kahnweiler in 1952. Kahnweiler also introduced Moore to galleries abroad, such as the Galerie Berggruen in Paris, where the sculptor had an exhibition in the spring of 1957.[6] GB

40
Henry Moore
Seated Figure 1954

Pencil on paper
56.1 × 38.2
Inscribed 'Moore | 54' b.l. in pencil and 'For Gustav + Elly. | From Henry Moore' b.r. in pencil
Presented by Gustav and Elly Kahnweiler 1974 and accessioned 1994
T06823

Provenance
Gift of the artist to Gustav and Elly Kahnweiler by January 1966 when lent to the Tate Gallery

Maquettes

At the beginning of his career Moore worked mostly in stone. Subscribing to the modernist ethos of 'truth to material', his early pieces were carved directly, and not made from models by assistants. However, he began to vary his approach from the mid-1930s, often modelling in clay and using these maquettes to create the final work. Eventually, he moved on to casting his work in bronze as well as carving it in stone or wood. Liberated from the constraints of carving, Moore had almost entirely eliminated drawing from his working process by the mid-1950s and explored his ideas through small maquettes. These had an intrinsic quality of immediacy or spontaneity and allowed him to imagine the finished product in the round. He said in 1968, 'with the kind of sculpture I do now, I need to know it from on top and from underneath as well as from all sides. And so I prefer to work out my ideas in the form of small maquettes which I can hold in my hand and look at from every point of view.'[7] In order to translate the scale of the work more effectively from portable to over life-size, he often made larger working models as an intermediate stage between the maquette and the finished sculpture.

Moore's maquettes were typically cast in bronze in editions of up to ten. The sculptor strove for monumentality in his work and tried to imbue the same quality in the small maquettes. He also took a great deal of care with their finish. Some were more polished than others, some darker, some greener. Moore did all the patination himself, treating the bronze with different acids to achieve different effects, then working on it by hand, rubbing and wearing it down. Kahnweiler regularly bought maquettes from Moore, who would reserve them for him even before they were cast. In August 1956 Moore wrote to him, 'I'm glad you and Elly like the Standing Figure and I'm saving the next "Fallen Warrior" for you when the cast comes from the foundry.'[8]

Of the four maquettes in the Kahnweiler Gift, *Maquette for Standing Figure* 1950, is the earliest. It exploits the ductile properties of bronze to the full, twisting and arching like a ribbon around large areas of empty space. Moore generated an interdependent spatial relationship between the void and the slender bronze that encloses it, creating a work which would have been impossible to make in stone. The sculpture, based on a drawing of 1948, was the last important work that originated from a drawing.

Maquette for Figure on Steps 1956, is related to *Draped Reclining Woman* 1957–8 (no.45), and shows an interesting contrast between the figure and the steps she is sitting on, the integrated architectural setting playing as important a compositional part as the figure itself. Although also using a step as a compositional setting, *Maquette for Fallen Warrior* 1956, makes an interesting contrast. While *Maquette for Figure on Steps* depicts a majestic figure in repose, *Fallen Warrior*, one of Moore's few male figures, is a tragic, writhing *contrapposto* figure, expressing energy and dynamism.

Reclining Figure: Bunched 1961 was not a model for a bronze sculpture but for one in travertine; its undulating shape lent itself to be replicated in the creamy veined marble. Moore was very much influenced by organic forms and often incorporated shapes derived from his observation of natural objects such as pebbles, bones and driftwood into his work.

In 1974 Kahnweiler and Sir Norman Reid, then Director of the Tate Gallery, discussed the desirability of identifying those maquettes in his collection that had no distinguishing foundry mark or signature and, after obtaining Moore's agreement, had a 'K' stamped under the bases of *Maquette for Standing Figure*, *Maquette for Figure on Steps* and *Maquette for Fallen Warrior*, which were unmarked (*Reclining Figure: Bunched* was already inscribed 'Moore 9/9').[9] GB

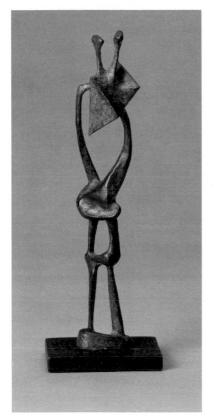

41
Henry Moore
Maquette for Standing Figure 1950

Bronze and wood
27.5 × 9.4 × 7.5
Letter 'K' punched under base,
edition of 7 plus 1, no.1/7
Bequeathed by Elly Kahnweiler
1991 to form part of the gift of
Gustav and Elly Kahnweiler and
accessioned 1994
T06827

Provenance
Purchased by Gustav and
Elly Kahnweiler July 1956
(letter from The Henry Moore
Foundation, Much Hadham,
to Tate, 13 October 2003)

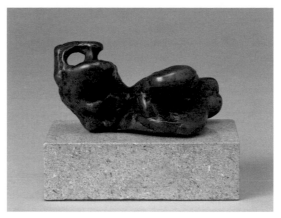

42
Henry Moore
Reclining Figure: Bunched 1961

Bronze
13 x 16.6 x 9.3
Cast inscription 'Moore 9/9'
under the left foot,
edition of 9 plus 1
Presented by Gustav and
Elly Kahnweiler 1974 and
accessioned 1994
T06826

Provenance
Purchased by Gustav and
Elly Kahnweiler July 1962
(letter from The Henry Moore
Foundation, Much Hadham,
to Tate, 13 October 2003)

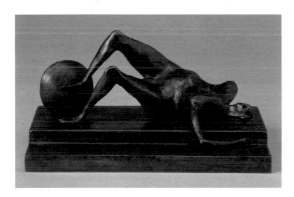

43
Henry Moore
Maquette for Fallen Warrior 1956

Bronze
14 × 15.5 × 26.5
Letter 'K' punched under base,
edition of 10 plus 1, no.2/10
Presented by Gustav and
Elly Kahnweiler 1974 and
accessioned 1994
T06824

Provenance
Purchased by Gustav and
Elly Kahnweiler July 1957
(letter from The Henry Moore
Foundation, Much Hadham,
to Tate, 13 October 2003)

44
Henry Moore
Maquette for Figure on Steps 1956

Bronze
16.7 × 18.2 × 16.3
Letter 'K' punched under base,
edition of 10
Bequeathed by Elly Kahnweiler
1991 to form part of the gift
of Gustav and Elly Kahnweiler
and accessioned 1994
T06828

Provenance
Purchased by Gustav and Elly
Kahnweiler November 1956
(letter from The Henry Moore
Foundation, Much Hadham,
to Tate, 13 October 2003)

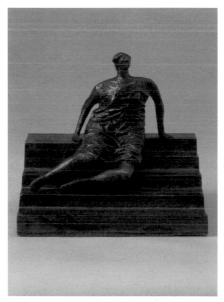

45
Henry Moore
Draped Reclining Woman 1957–8

Bronze
134.6 × 208.3 × 91.4
Cast signature 'Moore 2/6'
on top of base, edition of
6 plus 1
Presented by Gustav and
Elly Kahnweiler 1974 and
accessioned 1994
T06825

Provenance
Purchased by Gustav and Elly
Kahnweiler by March 1962
when first offered as a gift
to the Tate Gallery

Draped Reclining Woman 1957–8

The reclining figure was a major recurring theme in Moore's work. The sculptor liked its compositional and spatial freedom, as well as its ability to express repose. Moreover, he said, 'A reclining figure can recline on any surface. It is free and stable at the same time. It fits in with my belief that sculpture should be permanent, should last for eternity.'[10]

Moore's interest in drapery as a sculptural element dates back to the Second World War when, as an official 'war artist', he made drawings of people huddled in the shelters that had been improvised in London's Underground tunnels. His first visit to Greece in 1951, where he saw classical studies of draped figures, strengthened this interest and, as a result, he made a number of figures wearing draped clothing through the 1950s. The artist came to believe that drapery could make the shape of a figure both more expressive and more sculptural. In 1954 he stated: 'Drapery can emphasise the tension in a figure, for where the form pushes outwards ... it can be pulled tight across the form (almost like a bandage), and by contrast with the crumpled slackness of the drapery which lies between the salient points, the pressure from inside is intensified.'[11]

The classicising drapery covering this large reclining figure lends an air of timelessness to a sculpture which is nevertheless resolutely modern. At the same time, its rough texture and numerous creases – sinking and protruding, at times fine and delicate and at others large and heavy –

call to mind the uneven furrows and mounds of a hilly landscape. Moore compared folds of drapery, when seen close up, to the forms of mountains, 'which are the crinkled skin of the earth.'[12]

Kahnweiler first proposed making a gift to Tate of *Draped Reclining Woman* as early as 1962, stipulating that it should be lent to the Glyndebourne Opera House in East Sussex – which he and Elly enjoyed attending – for a period of twenty-five years after his death, provided that their productions continued to be of high quality. The sculpture now stands surrounded by irises and geraniums in Glyndebourne's Bourne Garden, a tropically themed garden with banana trees and giant ferns. Other casts of *Draped Reclining Woman* are in the Robert and Lisa Sainsbury Collection, Sainsbury Centre for Visual Arts, University of East Anglia, Norwich, the Bayerische Staatsgemäldesammlungen, Munich, the Staatsgalerie, Stuttgart, and the Norton Simon Museum of Art, Pasadena. The plaster working model is in the collection of the Henry Moore Sculpture Center, Art Gallery of Ontario, Toronto. GB

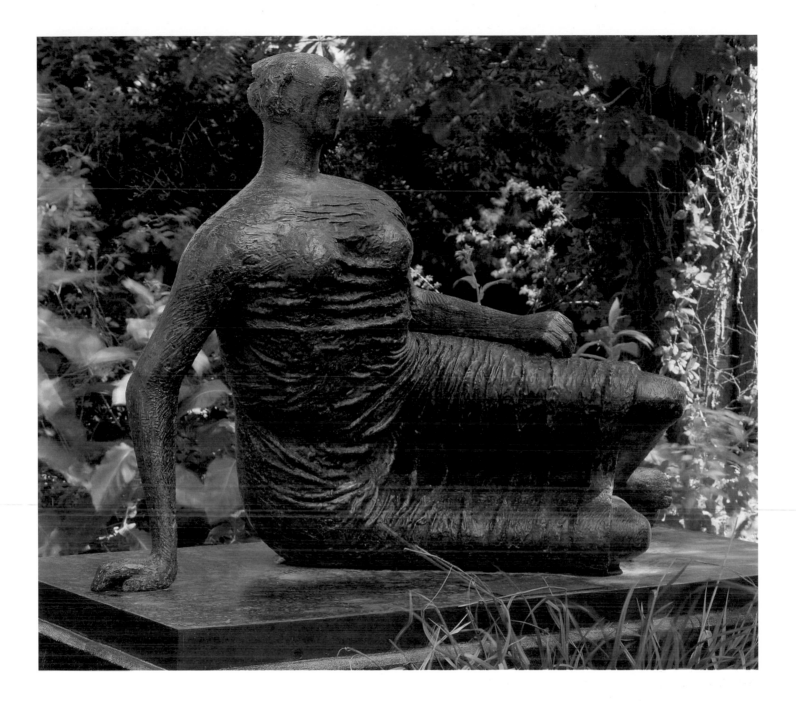

Pablo Picasso 1881–1973

Daniel-Henry Kahnweiler first encountered Pablo Picasso in the summer of 1907 thanks to a mutual friend, the German art historian and collector Wilhelm Uhde. Uhde had told Kahnweiler about a 'strange picture [by Picasso] that looked Assyrian'[1] and, his curiosity aroused, the art dealer went to see the young artist in his studio in the building known colloquially as Bateau Lavoir (or 'laundry boat') on rue Ravignan. Kahnweiler later said of this encounter:

> No one can ever imagine the poverty, the deplorable misery of those studios in rue Ravignan … The wallpaper hung in tatters from the unplastered walls. There was dust on the drawings and rolled-up canvases on the caved-in couch. Beside the stove was a kind of mountain of piled-up lava, which was ashes. It was unspeakable. There was also that large painting Uhde had told me about, which was later called 'Les Demoiselles d'Avignon,' and which constitutes the beginning of cubism. I wish I could convey to you the incredible heroism of a man like Picasso, whose spiritual solitude was truly terrifying, for not one of his painter friends had followed him. The picture he had painted seemed to everyone something mad or monstrous.[2]

Kahnweiler was, in his own words, 'overwhelmed' by this encounter and started to buy Picasso's work immediately.[3] Shortly afterwards he met Georges Braque and began to buy his work too. Kahnweiler has stated that he was immediately aware of the part cubism would play in the future development of art: 'I did not have the slightest doubt as to either the aesthetic value of these pictures or their importance in the history of painting, for although I did not know about the commercial aspect of painting, I did know painting'.[4]

Fernande Olivier, Picasso's companion between 1905 and 1912, wrote of the dealer, 'Kahnweiler was very Germanic, intelligent, determined and cunning … He wanted Picassos, Matisses, van Dongens, Derains and Vlamincks, and he managed to get them. He had a brilliant eye and sharp intelligence and actively courted young artists, attracting them to him by offering more than the other art dealers … But he would also bargain for hours on end, until the artist was beside himself with exhaustion and finally agreed to the reduction demanded.'[5] However, a genuine friendship

soon developed between the dealer and his artists, and Kahnweiler fondly recalled the atmosphere of the early years of cubism:

> *Picasso and Braque, of course, were still in Montmartre ... They would work; then they*
> *would meet at five o'clock and come down to my gallery in rue Vignon, and we would talk*
> *... We would go to Le Lapin Agile – in the winter, to that smoky cave where Freddie, with*
> *his long beard, would play the guitar and sing, in the summer, in the open air. I remem-*
> *ber those warm summer nights with Paris illuminated at our feet. That was our life;*
> *it was simple and carefree because ... we were sure of victory, we were sure of ourselves.*

Before the First World War Kahnweiler would visit Picasso in his Paris studio almost every day and Picasso regularly wrote to him when he was working in the South of France. The artist's correspondence was particularly assiduous in 1912, when his letters to the dealer covered a range of subjects embracing work, mutual friends and trivialities. On 4 July, for example, Picasso requested from Sorgues, 'Write to me, as I need to receive letters from friends ... tell Max Jacob that I really like him and that it doesn't mean anything if I don't write to him.'[6] The following month he informed Kahnweiler, 'I am making progress with the paintings I had started and am making some drawings ... I have bought the toothbrushes that I had told you about and recommend them to you. If you were a smoker I would also recommend to you Marseille pipes ...'[7]

At the beginning of their relationship, Kahnweiler was frustrated by Picasso's refusal to give him exclusive rights to his production and by the artist's insistence on keeping certain works for himself. Picasso only ever signed one exclusive contract with the dealer, in 1912. This contract, which was simply a letter from Picasso to Kahnweiler, specified that the artist agreed to sell his entire future production of paintings, sculptures, drawings and prints to Kahnweiler for a period of three years, excluding the works he already had in his studio. However, Picasso reserved the right to accept commissions and to keep five paintings a year as well as any drawings he judged necessary for his work. He also specified that only he would be allowed to decide whether a painting was finished and therefore available for sale.[8]

After Kahnweiler returned to Paris in 1920, having been in exile during the war, their relationship was somewhat cooler. Picasso had been selling his work to the dealer Paul Rosenberg, who was able to pay higher prices. Although he started to sell some work to Kahnweiler again in 1923, he reserved most of his production for Rosenberg until 1939. It was only at this date that he and Kahnweiler reached 'another complete understanding'.[9] This time, however, there was no written agreement and Picasso would regularly sell his work to others.

After the Liberation Picasso continued to sell to other galleries, although Kahnweiler had the rights to his lithographs. Little by little the dealer became Picasso's 'ambassador to the outside world',[10] especially after the artist left Paris for the South of France, and was constantly flooded with requests for works, authentications, exhibitions and meetings with Picasso, which he would communicate to the artist together with his recommendations. Kahnweiler's telephone calls were among the few that Picasso would take. Their sixty-six-year-long relationship was as strong as it was stormy. According to Kahnweiler's biographer Pierre Assouline, when he heard that Picasso had died, the dealer 'was stunned by the news. For a long time he had refused to even consider that Picasso might die. He would not see anyone, nor read articles, nor give interviews ... The art dealer was so identified with the artist that, at Kahnweiler's death six years later, a newspaperman would write: "With Kahnweiler, it is Picasso we have lost once more."'[11]

After the Second World War Gustav Kahnweiler arranged to buy from his brother a small number of Picasso prints which he sold privately and through his friend, the dealer Heinz Berggruen. The closeness of the relationship between the artist and 'le petit Kahnweiler', as he was known, is uncertain, although the two were amicable, as indicated by a humorous inscription by Picasso in an exhibition catalogue: 'To Elly and Gustav (the ne'er-do-well), Picasso, Paris 18 May 1953'.[12] GB

46
Pablo Picasso
Head of a Young Boy 1945
Tête de jeune garçon

Lithograph on paper
30.7 × 22.7
Inscribed 'Picasso' b.r. and '44/50'
b.l. in pencil; and 'A Elly Zette'
b.c. under mount in purple ink
[Zette was the family nickname
of Louise Leiris]
Bequeathed by Elly Kahnweiler
1991 to form part of the gift of
Gustav and Elly Kahnweiler and
accessioned 1994
P11364

Provenance
Galerie Louise Leiris, Paris;
gift of Louise Leiris to Elly
Kahnweiler 1947

47
Pablo Picasso
Black Jug and Skull 1946
Le Pichet noir et la tête de mort

Lithograph on paper
32.2 × 44
Inscribed '39/50 | Picasso'
b.l. in pencil
Bequeathed by Elly Kahnweiler
1991 to form part of the gift of
Gustav and Elly Kahnweiler and
accessioned 1994
P11365

Provenance
Galerie Louise Leiris, Paris;
acquired by Gustav and Elly
Kahnweiler by January 1960
when lent to the Tate Gallery

Faun Revealing a Sleeping Woman (Jupiter and Antiope, after Rembrandt) 1936

Faun Revealing a Sleeping Woman is the last print in the series known as the *Vollard Suite*. This series was the culmination of the collaboration between Picasso and Ambroise Vollard, who had been his first dealer and for whom he had illustrated a number of books. It consists of one hundred prints, made in the period from 1930 to 1937, ninety-seven of which were selected by Picasso and given to Vollard in exchange for a number of his early works; the remaining three were portraits of Vollard himself. Picasso used a variety of techniques in this series, such as etching, aquatint, drypoint, wash, burin and scraper. He depicted a variety of themes among which the sculptor in his studio and scenes from Greek mythology, particularly relating to the Minotaur, predominate.

A set of ten prints from the *Suite* was first published in an edition of fifteen by the atelier of Roger Lacourière in Paris in 1937. In 1939 Lacourière printed the definitive edition, which consisted of at least two or three artist's proofs on Montval laid paper; three impressions on vellum paper, signed and numbered by the artist; fifty impressions on Montval laid paper measuring 50 × 76 cm, predominantly signed; and two hundred and fifty impressions on off-white Montval laid paper bearing the watermark 'Vollard' or 'Picasso', some of which were signed.

Made on 12 June 1936, this is the sixth and final state of *Faun Revealing a Sleeping Woman*. Through the six states the image remained fundamentally the same, while the simple black lines and light shading of the earlier states developed into rich tones of grey that depicted a night-time scene with a dramatic play of light and dark. The faun himself underwent a dramatic transformation, becoming more attractive and classical-looking with every state, finally becoming, as Brigitte Baer has described him, 'a god-like personification of beauty'.[13] An intriguing change is in the minor detail of the plant in front of the balcony: at first a strawberry plant, it later became basil, which, according to Mediterranean folklore, has the magical power to transform animals into wonderful creatures, especially during a full moon.[14]

This print is directly based on Rembrandt's engraving *Jupiter and Antiope* 1659. Picasso had dealt with mythological subjects in his work before, and in 1930 was commissioned by the publisher Albert Skira to illustrate Ovid's *Metamorphoses*. In Greek mythology, Antiope was a daughter of Nycteus, King of Thebes. Zeus (known as Jupiter in Roman mythology) was attracted by her beauty and came to her in the guise of a satyr (a half-human creature with the horns, legs and hooves of a goat, known as a faun in Roman mythology), after which she conceived twins, Amphion and Zethus. Forced to abandon her children and flee Thebes, she was eventually brought back to become enslaved to her evil stepmother Dirce. Upon reaching maturity, her sons, who had been secretly brought up by shepherds, exacted a terrible revenge upon Nycteus and particularly Dirce, who was tied to the horns of a wild bull.

Many commentators have remarked on the influence that Picasso's life and circumstances had on his work. D.-H. Kahnweiler, for example, described his work as 'fanatically autobiographical'.[15] The Minotaur and the lustful faun in Picasso's work may be seen as ciphers for the artist himself. *Faun Revealing a Sleeping Woman* was made as Picasso's relationship with his lover and muse of ten years Marie-Thérèse Walther was petering out, affection for her having replaced passion. Here the faun – who may stand for Picasso – gently uncovers the sleeping Antiope – who may represent Marie-Thérèse – without disturbing her. This print has been described as 'a work that looks back nostalgically on their stay in Juan-les-Pins [in April 1936] and on a passion that had changed ... the most successful print in the *Suite Vollard* and one of the most beautiful in the artist's engraved work.'[16] GB

48
Pablo Picasso
Faun Revealing a Sleeping Woman (Jupiter and Antiope, after Rembrandt) 1936
Faune dévoilant une dormeuse (Jupiter et Antiope, d'après Rembrandt)

Etching and aquatint on paper
31.6 × 41.7
Inscribed 'Picasso' b.r. in pencil
Presented by Gustav and
Elly Kahnweiler 1974 and
accessioned 1994
P11360

Provenance
... ; Gustav and Elly Kahnweiler by
January 1960 when lent to the
Tate Gallery

Dove 1949

The Spanish Civil War played a crucial role in Picasso's outlook. Daniel-Henry Kahnweiler has stated that Picasso had hitherto been the 'most apolitical man' he had ever known: 'He had never thought about politics at all, but the Franco uprising was an event that wrenched him out of this quietude and made him a defender of peace and liberty.'[17] After he painted his famous response to the German bombing of the Basque village of Guernica in 1937, Picasso became a symbol of anti-fascism and particularly of the struggle against fascism by artists and intellectuals. At the end of the Second World War he joined the Communist Party and attended a number of World Peace Congresses (in Wroclaw, Paris, Sheffield and Rome) between 1948 and 1951. There he would meet with like-minded intellectuals and artists, such as Renato Guttuso. Picasso made a brief speech at the 1950 Peace Congress in Sheffield which he concluded, 'I stand for life against death; I stand for peace against war.'[18]

Picasso made *Dove* on 9 January 1949 in the atelier of the printmaker Fernand Mourlot. It is a simple yet striking composition of a white dove on a black background, masterfully rendered in lithographic ink wash. Mourlot has called it 'one of the most beautiful lithographs ever achieved; the soft tones attained in the feathers ... are absolutely remarkable. This plate ... conveys the maximum that can be obtained with lithographic ink used as wash.'[19] A favourite of Gustav and Elly Kahnweiler's, *Dove* hung over their bed at Alderbourne Manor, Gerrards Cross.

Dove was published by the Galerie Louise Leiris in an edition of five artist's proofs, plus fifty signed and numbered prints on white Arches wove paper, of which this is number nine. The work was used for the poster of the 1949 Paris Peace Congress, and became not only the symbol of the Peace Congresses but also of the ideals of world communism.[20] The Paris Peace Congress opened on 20 April. The day before, Picasso's companion Françoise Gilot had given birth to his fourth child, who was named Paloma, the Spanish word for 'dove'. GB

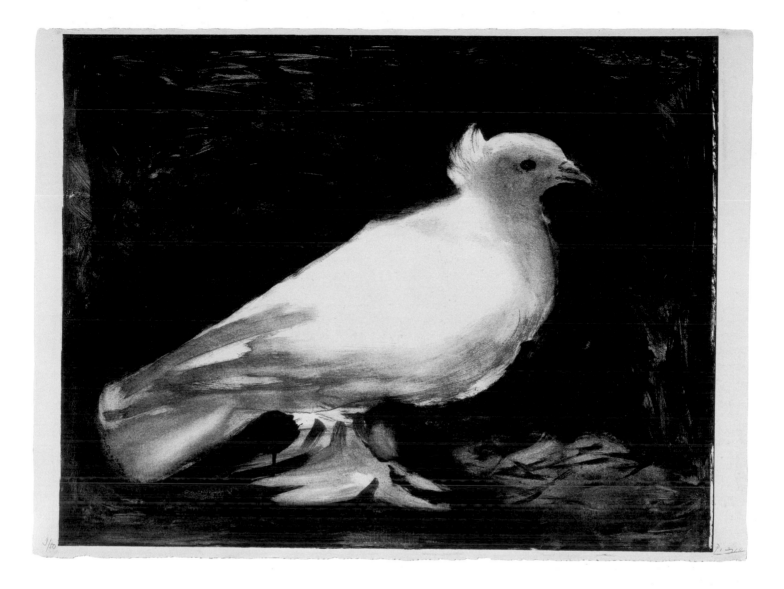

49
Pablo Picasso
Dove 1949
La Colombe

Lithograph on paper
54.7 × 68.7
Inscribed 'Picasso' b.r. in pencil
and '9/50' b.l. in pencil
Bequeathed by Elly Kahnweiler
1991 to form part of the gift of
Gustav and Elly Kahnweiler and
accessioned 1994
P11366

Provenance
Galerie Louise Leiris, Paris;
acquired by Gustav and Elly
Kahnweiler by December 1951
when lent to the Tate Gallery

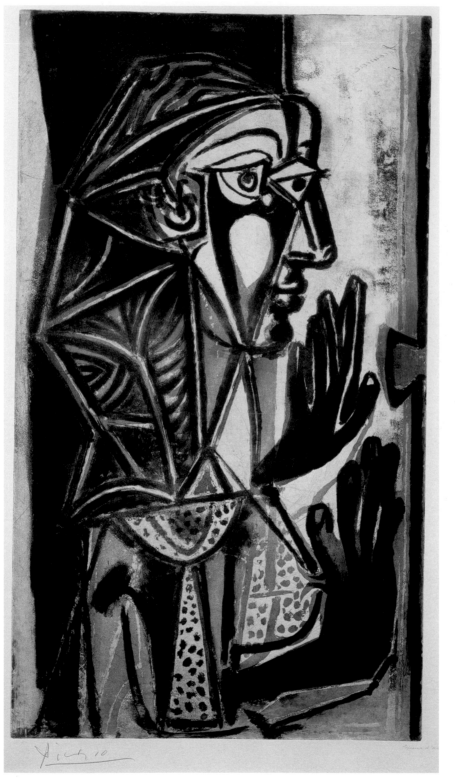

50
Pablo Picasso
Woman at the Window 1952
La Femme à la fenêtre

Aquatint and drypoint on paper
83 × 47.5
Inscribed 'Picasso' b.l. and
'Epreuve d'artiste' b.r. in pencil
Presented by Gustav and
Elly Kahnweiler 1974 and
accessioned 1994
P11362

Provenance
Galerie Louise Leiris, Paris;
acquired by Gustav and Elly
Kahnweiler by January 1967
when lent to the Tate Gallery

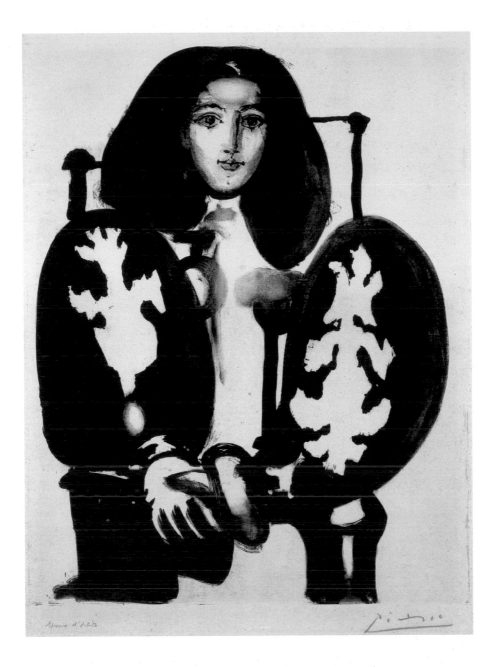

51
Pablo Picasso
**Woman in an Armchair No.1
(The Polish Cloak)** 1949
*Femme au fauteuil no.1
(Le Manteau polonais)*

Lithograph on paper
68.8 x 51.1
Inscribed 'Picasso' b.r. and
'Epreuve d'artiste' b.l. in pencil;

and 'A Elly et à Gustave | pour
leurs Noces d'Argent | avec mon
affection | Heini Mars 1950'
across lower edge of verso
Presented by Gustav and Elly
Kahnweiler 1974 and accessioned
1994
P11361

Provenance
Galerie Louise Leiris, Paris; gift of
Daniel-Henry Kahnweiler to
Gustav and Elly Kahnweiler 1950

The Studio 1955

A major work from the 1950s, *The Studio* occupied pride of place in Gustav and Elly Kahnweiler's sitting room at Alderbourne Manor. It depicts the studio in the villa called La Californie near Cannes, where Picasso and Jacqueline Roque had moved in the summer of 1955. A large nineteenth-century villa at the foot of the Sainte-Victoire mountain, La Californie was built in Art Nouveau style and had extensive views towards the coast. Picasso used the large main salon on the ground floor as his studio. It was also the place where he received and entertained friends and dealers.

Between 23 and 31 October 1955 Picasso depicted views of his studio eleven times, returning to the same subject on 12 November for a twelfth canvas. With the exception of the twelfth work, all the *Studio* paintings are in portrait format, but vary in size, from 73 × 54 cm to 195 × 130 cm. Kahnweiler's work was painted over two days, 30 and 31 October (on 30 October Picasso also completed two other *Studios*). Picasso applied the paint directly on the canvas with a brush and a palette knife, using the end of the brush to scrape the paint and reveal the ground in several places. In some background areas, particularly the window, the paint was applied thinly and the ground was occasionally left visible, while in others, such as the sculpted head, Picasso used a thick impasto. The image represents particular aspects of the studio – the ornate Art Nouveau window, certain tools and even a guitar hanging on the wall[21] – elements which were repeated in all twelve studio canvases.

Although Picasso returned to the theme of the artist in the studio countless times, this series is unusual because the studio itself becomes the main protagonist of the painting. The studio is empty but Picasso's presence is strongly felt in the tools and the sculpted head on a modelling stand. The studio had been a favourite subject for his friend and rival Henri Matisse, and it has been suggested that Picasso adopted it at this time as a direct response to the artist's death the previous year. Art historian Michael FitzGerald has written that this series 'is steeped in Matisse's approach – the central window that establishes the contrast between a brilliant natural exterior and a sombre interior, and even the profusion of linear patterns scratched into the walls and floors with the butt of a brush, making the room as visually dynamic as the blazing yellows and greens outside.'[22] The sheer decorativeness of the window and the exotic palms it frames also recall the opulent decoration of Matisse's *Odalisque* paintings. When Gustav first saw *The Studio*, he apparently remarked on its Matisse overtones to Picasso, who is said to have replied: 'Well, I thought, as Matisse was now dead, there was no harm in moving into his territory!'[23]

All twelve canvases were shown in an exhibition of recent works by Picasso at the Galerie Louise Leiris in the spring of 1957. In the introduction to the catalogue Daniel-Henry Kahnweiler rendered homage to his old friend: 'For Picasso only the present instant exists; that is the secret of his constant "availability". I have had the privilege of mixing with him, of being his friend, for fifty years. This friendship has enriched my life. I thank him for that.'[24] GB

52
Pablo Picasso
The Studio 1955
L'Atelier

Oil on canvas
80.9 × 64.9
Inscribed 'Picasso' b.l. in grey paint, '30.10.55. | 31.IV' t.r. of verso in black paint
Presented by Gustav and Elly Kahnweiler 1974 and accessioned 1994
T06802

Provenance
Galerie Louise Leiris, Paris; acquired by Gustav and Elly Kahnweiler by May 1957 when lent to the Tate Gallery

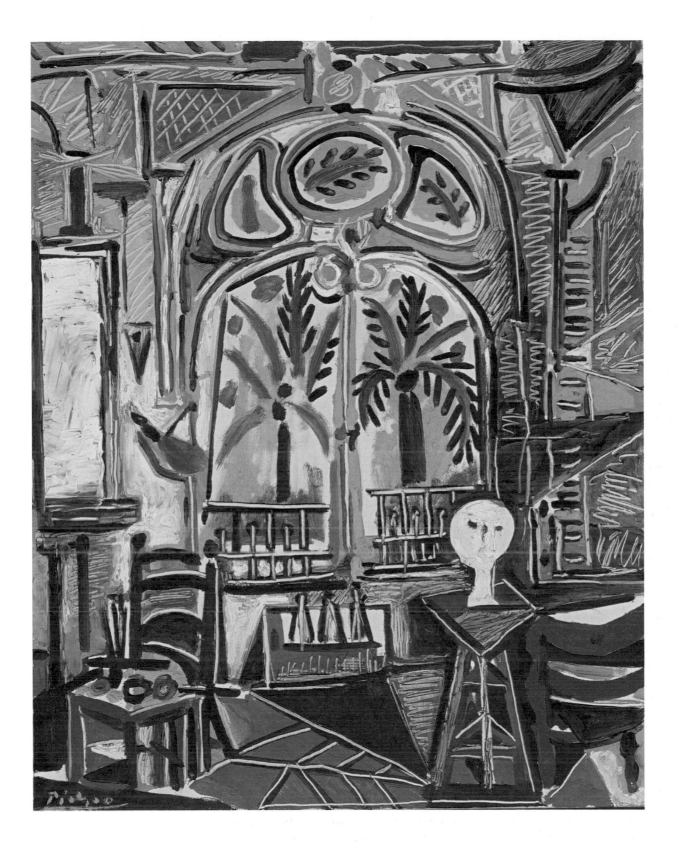

53
Pablo Picasso
Portrait of a Woman after Cranach the Younger 1958
Buste de femme d'après Cranach le Jeune

Linocut on paper
64.5 × 53.3
Inscribed 'Picasso' b.r. in red crayon, 'Epreuve d'artiste' b.l. in pencil
Bequeathed by Elly Kahnweiler 1991 to form part of the gift of Gustav and Elly Kahnweiler and accessioned 1994
P11368

Provenance
Galerie Louise Leiris, Paris; purchased by Gustav and Elly Kahnweiler by January 1960 when lent to the Tate Gallery

Portrait of a Woman after Cranach the Younger 1958

Although he had already made one linocut in 1939 (*Pour la Tchécoslovaquie. Hommage à un pays martyr*), Picasso only started exploring this technique in earnest during 1953 and 1954, with the printer Hidalgo Arnéra in Vallauris, Provence. At this time he began to experiment with making linocuts in different colours on separate blocks, which he would then superimpose on the same sheet of paper. He first attempted *Portrait of a Woman after Cranach the Younger* in two colours on 3 July 1958, but the following day he returned to the same subject more ambitiously. On 4 July he made five different linoleum blocks – sepia, yellow, red, blue and black – to be superimposed on each other in that order. He then proceeded to print different proofs, in the process making two different states of the colour blocks and three of the black in order to arrive at the final image. The final version was printed on white Arches wove paper in an edition of approximately fifteen artist's proofs (of which this is one) plus fifty signed and numbered copies, published by the Galerie Louise Leiris.

Daniel-Henry Kahnweiler has explained the genesis of this work: 'One of Picasso's notable characteristics was his need to transform existing works of art, to compose "variations on a theme", as it were. His point of departure was often simply a reproduction in a book; or even a postcard sent by myself, such as Cranach the Younger's *Portrait of a Woman* 1564 in Vienna (collection Kunsthistorisches Museum), which became his first linocut in colour. Among other things, what struck him in particular about this painting was the way the woman's shadow "rhymes" with the upper part of her body. "How pleased Gris would have been", he said to me ... This need to transform was certainly an important characteristic of Picasso's genius.'[25] GB

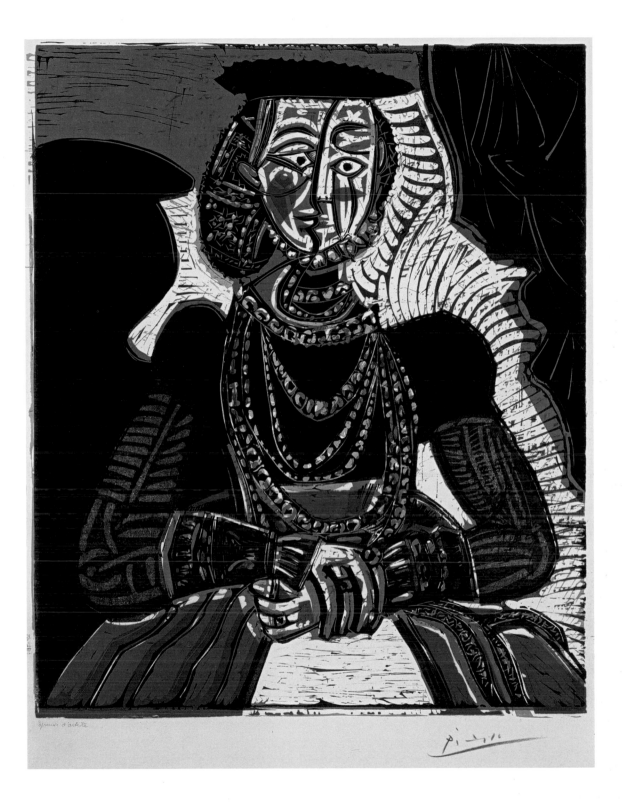

Épreuve d'artiste Picasso

54
Pablo Picasso
Neo-Classical Painter in his Studio
1963
Peintre néo-classique dans son atelier

Etching on paper
42.4 × 57.5
Inscribed 'Picasso' b.r. and
'Epreuve d'artiste' b.l. in pencil
Presented by Gustav and
Elly Kahnweiler 1974 and
accessioned 1994
P11363

Provenance
Galerie Louise Leiris, Paris;
purchased by Gustav and Elly
Kahnweiler by January 1967
when lent to the Tate Gallery

55
Pablo Picasso
Dance of the Banderillas 1954
La Danse des banderilles

Lithograph on paper
50.2 × 65.2
Inscribed 'Picasso' t.r. and
'48/50' b.r. in pencil
Bequeathed by Elly Kahnweiler
1991 to form part of the gift
of Gustav and Elly Kahnweiler
and accessioned 1994
P11367

Provenance
Galerie Louise Leiris, Paris;
purchased by Gustav and Elly
Kahnweiler by January 1960
when lent to the Tate Gallery

56
Pablo Picasso
Bullfight Scene 1960
Scène de corrida

Brush and ink on paper
48 × 62.3
Inscribed '25.2.60. | X Picasso'
t.l. in black ink
Presented by Gustav and
Elly Kahnweiler 1974 and
accessioned 1994
T06803

Provenance
Galerie Louise Leiris, Paris;
acquired by Gustav and Elly
Kahnweiler by January 1962
when lent to the Tate Gallery

Notes

A Gesture of Appreciation
Jennifer Mundy

My thanks are owed to Sir Alan Bowness, Peter J. St.B. Green, James Mayor and Sir Norman Reid for their helpful comments on an early draft of the essay.

1 Letter from Gustav Kahnweiler to Sir Norman Reid, 10 January 1974. References to unpublished correspondence and lists in this essay are drawn from papers held in the Hyman Kreitman Research Centre, Tate (Kahnweiler Bequest Files and Kahnweiler Loans-in Files).

2 Trust Deed, signed 12 March 1974.

3 John Richardson described Gustav Kahnweiler as 'suave', and recalled that the collector and art historian Douglas Cooper had thought of the latter as 'almost a playboy' because his lifestyle allowed him to stay in the very best hotels in the most fashionable cities of Europe (conversation, 26 November 2003).

4 The archives of the Galerie Louise Leiris, Paris, are currently not available to researchers. Alfred Flechtheim left his papers to his friend Freddie Mayor, of the Mayor Gallery, London, but these were destroyed by bombing during the Second World War. The records of Gustav's military service in the First World War were also destroyed by bombing.

5 Peter Jellinek, a close friend, burned Gustav Kahnweiler's diaries after his death, at the latter's request (conversation, September 2003).

6 Gustav Kahnweiler was interviewed by Pierre Assouline for his *An Artful Life: A Biography of D.H. Kahnweiler 1884–1979*, trans. Charles Ruas, New York 1991 (French edition, Paris 1988), and by Gerhard Leistner, 'Interview mit Gustav Kahnweiler (London, November 1986)', in *Alfred Flechtheim: Sammler. Kunsthändler. Verleger*, exh. cat., Kunstmuseum Düsseldorf 1987, p.23.

7 Roland Penrose had a small surrealist collection in the early 1930s. This was significantly extended in 1937 by his purchase of the René Gaffé collection that included twelve cubist Picassos, and of Paul Eluard's surrealist collection in 1938. The other major collector in Britain before 1970 was E.J. Power, who amassed a great collection in the 1950s and 1960s of contemporary international art (see J. Mundy, 'The Challenge of Post-War Art: The Collection of Ted Power', in *Brancusi to Beuys: Works from the Ted Power Collection*, exh. cat., Tate Gallery, London 1996). Douglas Cooper had an exceptional cubist collection but moved to France after the war. Although individual collectors bought one or two works, it remains the case that cubism was not collected in any depth in Britain.

8 Alan Bowness, 'Gustav Kahnweiler', *Independent*, May 1989.

9 In a letter to Lord Gowrie urging him to consider a knighthood for Kahnweiler, Sir Alan Bowness described Kahnweiler as 'the most generous benefactor that the Tate Gallery has had in the last fifty years' (letter dated 5 August 1983).

10 Assouline writes that Daniel-Henry Kahnweiler was always intellectually more interested in Christianity than in the religion of his forefathers (Assouline 1991, p.278). However, his experience of the anti-semitism of French right-wing groups in 1936 led him to re-evaluate his position: 'I had not known that I was Jewish. No one had told me, and the fact of being Jewish was of no importance to me because I don't believe in the theory of "races". Now I'm learning that I was wrong, that I am Jewish and that there are "races". It won't make a "patriot" of me, and I don't have any inclination to become a martyr. I have every intention of returning blow for blow. The most effective way of doing that is to support those who think I am the same as they are – the parties of the left, the Popular Front – and to struggle alongside them against the common enemy, "fascism", to call it by its ordinary name' (letter to the poet Max Jacob, quoted in ibid., pp.278–9). In 1941 Gustav Kahnweiler chose to have his army record adjusted to read 'agnostic' instead of Jewish. Gustav and Elly's wills provided for a sum of money to be left to the Council of Christians and Jews, an organisation dedicated to the reconciliation of the two faiths.

11 Ibid. p.125.

12 Auguste Forchheimer (née Kahnweiler) and her husband were in New Orleans at the time of the birth of their son Peter in late 1915. After the ending of the war they moved back to Frankfurt, and it would seem from this letter that Gustav Kahnweiler lived with them c.1920. In 1925 Peter was diagnosed with insulin-dependent diabetes mellitus and was among the first to benefit from a new treatment involving regular injections of insulin extracts. It is not known when the family left Germany but it may have been well have been the same time as Gustav, that is, in late 1933. It is known that Peter attended a French school in Lausanne, Switzerland, before studying natural sciences at Cambridge University from 1934 to 1937. Later, Peter Forsham, as he was then known, became a leading specialist in the field of diabetes control. Professor Emeritus at the University of California, he died in 1995.

13 Quoted in *Alfred Flechtheim* 1987, p.51.

14 Ibid., p.165.

15 Ibid., p.51.

16 These dates are based on references to the gallery in Flechtheim's magazine *Der Quershnitt*.

17 Quoted in *Alfred Flechtheim* 1987, p.23.

18 Christian Zervos, 'Entretien avec Alfred Flechtheim', in *Cahiers d'Art*, Paris 1927, reproduced in *Alfred Flechtheim* 1987, p.45. Flechtheim called himself a 'propagandist of French art', and aimed to do for artists such as Picasso, Braque, Léger and Gris, what the German dealer Paul Cassirer had done for the French Impressionists a generation earlier.

19 Leistner, p.23.

20 Quoted in Assouline 1991, p.147.

21 See Christopher Green, *Cubism and its Enemies: Modern Movements and Reaction in French Art, 1916–1928*, New Haven and London 1987, p.136.

22 See *Alfred Flechtheim* 1987, p.173. The lithographs were *Street in Hérouville* and *Verville*, both of 1921.

23 Conversation, July 2003.

24 Masson's multi-titled *Man's Head*, *Nude Study*, *Landscape* or *Abstraction Composition* (Sotheby's, London, 1 December 1994, lot 245) was dedicated 'A Gustave et Elly, pour leur anniversaire (vingt-cinq ans de mariage)'.

25 Daniel-Henry Kahnweiler with Francis Crémieux, *My Galleries and Painters*, trans. Helen Weaver, London 1971, p.105.

26 Daniel-Henry Kahnweiler, 'Preface', in *Paintings from France*, exh. cat., Leicester Galleries, London, 1953, p.4.

27 Daniel-Henry Kahnweiler, 1953, p.5.

28 Conversation with Peter Jellinek, September 2003.

29 *Alfred Flechtheim* 1987, p.90 n. 242.

30 Ibid., p.24.

31 Conversation with Sir Francis Newman, 12 December 2003.

32 Leistner, p.24.

33 J.B. Manson, 'Mr Frank Stoop's Modern Pictures', in *Apollo*, vol.x, no.57, Sept. 1929, p.129.

34 Geoffrey Grigson, *The Arts Today*, London 1935, p.71.

35 Leistner, p.23.

36 Conversation with Mr James Mayor (28 November 2003). I am very grateful to him for his permission to consult the records of the Mayor Gallery.

37 This amendment was made in September 1941. A copy of Kahnweiler's army record was generously supplied by the Army Personnel Centre.

38 An invoice in Tate's records of Kahnweiler loans indicates that Alfred Hecht made some of the distinctive 1950s frames for a number of works in the collection.

39 Conversation (27 November 2003).

40 Letter from a curator of the Kunstmuseum Basel to Henry Moore, dated 13 March 1952: 'Yesterday Monsieur Gustav Kahnweiler visited our museum and informed me that you would send us your sculpture and asked me to pay you directly ... Monsieur Kahnweiler offered us your work for 300 guineas' (Henry Moore Foundation).

41 This section is indebted to James Hyman, 'The Third Way: Renato Guttuso and Realism in Europe', 2003, www.jameshyman fineart.com/pages/archive /information/509.html

42 In a listing of naturalised aliens, Kahnweiler's profession is given as 'art historian' (London Gazette, 19 December 1947, p.6011).

43 Letter from Gustav Kahnweiler to Sir John Rothenstein, dated 11 December 1951.

44 See Frances Spalding, The Tate: A History, London 1998, p.126.

45 Letter dated 27 June 1958.

46 'At home Gustav and Elly were very relaxed and we were their guests one year in Mirren. He was still skiing though over eighty. Two metres of snow fell while we were with them and we have photographs of him (and us) digging ourselves out of the house' (letter dated 13 December 2003).

47 Letter from Sir Norman Reid to Daniel-Henry Kahnweiler, dated 10 February 1969: 'I had a visit from your brother Gustav just before he left for Switzerland and we spoke about the possibility of getting an important sculpture by Laurens for the Tate.'

Georges Braques

1 From 1924 works by Braque were included in mixed exhibitions at the Galerie Flechtheim in Berlin in 1925, 1929 and 1930

2 Herschel B. Chipp, Georges Braque: The Late Paintings 1940–1963, exh. cat., Phillips Collection, Washington D.C., 1982, p.20.

3 See Braque: Oeuvres de Georges Braque (1882–1963), exh. cat., Musée national d'art moderne, Centre Georges Pompidou, Paris 1982, p.134.

4 Bernard Zurcher, Georges Braque: Life and Work, trans. Simon Nye, New York 1988, p.193.

5 Dennis Adrian, 'Georges Braque's Monumental Still-lifes', Art News, vol.71, no.7, Nov. 1972, p.33

6 Braque fell ill and had an operation in the summer of 1945, followed by a long convalescence. It is thought that he did not paint again until spring 1946 (Douglas Cooper, Braque: The Great Years, exh. cat., Art Institute of Chicago, Oct. – Dec. 1971, pp.84–5).

7 Quoted in Chipp, p.22.

8 Georges Braque: Oeuvre graphique original. Hommage de René Char, Geneva 1958, n.p.

9 Quoted in John Golding, 'The Late Paintings: An Introduction', in Braque: The Late Works, exh. cat., Royal Academy of Arts, London 1997, p.10.

César

1 Douglas Cooper, César, Botensee-Verlag, Ameiswil 1960.

Cecil Collins

1 Cecil Collins, diaries, Tate Archive TGA 923.6.2.2–12.

2 Cecil Collins, notes dated c.1951, Tate Archive TGA 923.8.21.1.

3 Richard Morphet, The Prints of Cecil Collins, exh. cat., Tate Gallery, London 1981, p.9.

Juan Gris

1 Daniel-Henry Kahnweiler, Juan Gris: His Life and Work, trans. Douglas Cooper, London 1969, p.190.

2 Daniel-Henry Kahnweiler, 'Preface' in Juan Gris 1887–1927, exh. cat., Marlborough Fine Art Ltd, London 1958, [p.3].

3 Letters of Juan Gris [1913–1927], collected by Daniel-Henry Kahnweiler, trans. and ed. Douglas Cooper, London 1956, p.23, n.1.

4 Kahnweiler 1969, p.45.

5 Letter dated 25 August 1919, in Letters of Juan Gris, p.190.

6 Ibid., p.62.

7 Kahnweiler 1969, p.146.

8 Letters of Juan Gris, pp.85–6.

9 Ibid., pp.89–90.

10 Reply to a questionnaire of 1925, repr. in Kahnweiler 1969, p.202.

11 The painting has a Galerie Flechtheim (Berlin and Düsseldorf) label on it and it is likely that it was sent to him via his German connections. The same may apply to the three gouaches and Pierrot with Book that also have these labels.

Renato Guttuso

1 Quoted in Fabio Carapezza Guttuso, 'Renato Guttuso: Ragione poetica e civile', Fabio Carapezza Guttuso et al., Guttuso, Milan 1999, p.29.

2 James Hyman, 'A "Pioneer Painter": Renato Guttuso and Realism in Britain', Guttuso, exh. cat., Whitechapel Art Gallery, London 1996, p.39.

3 Guttuso 1942, quoted in Enrico Crispolti, Guttuso nel disegno: Anni Venti/Ottanta, Rome 1983, p.10.

4 Crispolti, ibid, p.10.

5 Quoted in Enrico Crispolti, Catalogo ragionato generale dei dipinti di Renato Guttuso, vol.2, Mondadori, Milan 1984, p.xxvii.

6 Hyman, in Guttuso, 1996, p.40.

7 Quoted in ibid, p.41.

8 Ibid, p.47.

9 Ibid, p.44.

10 One of many books and catalogues on Guttuso in the Kahnweilers' library, this was Giuseppe Marchiori, Renato Guttuso, Edizioni d'Arte Moneta, Milan 1952 (Tate Archive).

11 Fabio Carapezza Guttuso, communication to Tate, 4 Oct. 2003.

12 Letter from Gustav Kahnweiler to Moore, Hotel Moresco, Ischia, 12 May 1963 (The Henry Moore Foundation, Much Hadham).

13 Renato Guttuso: Mostra antologica dal 1931 ad oggi, exh. cat., Palazzo della Pilotta, Parma 1963 (Tate Archive).

14 Quoted in http://www.museogut-tuso.it/uno.html.

15 Crispolti 1983, p.10.

16 Carapezza Guttuso 1999, p.29.

Paul Klee

1 'Personal Recollections of Paul Klee', in Paul Klee, exh. cat., Buchholz Gallery and Willard Gallery, New York 1940, n.p.

2 Agnès Angliviel de la Beaumelle, 'Paul Klee', in Die Sammlung Kahnweiler: Von Gris, Braque, Léger und Klee bis Picasso, exh. cat., Kunstmuseum im Ehrenhof, Düsseldorf 1994–5, p.158.

3 Ibid., p.161

4 Jürg Spiller (ed.), Paul Klee: The Thinking Eye. The Notebooks of Paul Klee, London 1961, p.24.

Marie Laurencin

1 Christopher Green, Léger and the Avant-Garde, New Haven and London 1976, p.6.

2 Roger Allard, Marie Laurencin et son oeuvre, Paris 1921, p.6.

3 Heather McPherson, 'Marie Laurencin: An Undividedly Feminine Psyche', in Douglas K.S. Hyland and Heather McPherson, Marie Laurencin: Artist and Muse, exh. cat., Birmingham Museum of Art, Birmingham, Alabama 1989, p.29

4 Elizabeth Louise Kahn, Marie Laurencin: Une femme inadaptée in Feminist Histories of Art, Aldershot 2003, p.xx.

5 Quoted in Hyland and McPherson 1989, p.61.

6 Allard 1921, p.7.

7 Elizabeth Otto, 'Memories of Bilitis: Marie Laurencin beyond the Cubist Context', Genders Online Journal, no.36, 2002 (http://www.genders.org/ g36/g36_otto.html).

8 Kahn 2003, p.xvii.

9 Letter from Peter Jellinek to Tate, 18 July 1991.

10 No.0894, crossed off and replaced by hand with the number 1921.

Henri Laurens

1 Letter dated 30 Oct. 1919, quoted in Henri Laurens: Le Cubisme. Constructions et papiers collés 1915–19, exh. cat., Centre Georges Pompidou, Musée national d'art moderne, Paris 1985, p.21.

2 Valori Plastici, Feb.–March 1919

3 Daniel-Henry Kahnweiler with Francis Crémieux, My Galleries and Painters, trans. Helen Weaver, London 1971, p.96. The first solo exhibition that Kahnweiler gave Laurens was in 1958 (Henri Laurens: Sculptures en Pierre 1919–43,

Galerie Louise Leiris, Paris).

4 Quoted in Christopher Green, *Cubism and its Enemies: Modern Movements and Reaction in French Art, 1916–1928*, New Haven and London 1987, p.46.

5 Quoted in *Donation Louise et Michel Leiris: Collection Kahnweiler-Leiris*, exh. cat., Centre Georges Pompidou, Musée national d'art moderne, Paris 1984, p.104.

6 The stone version titled *Le Boxeur* is reproduced in *Henri Laurens 1885–1954: 60 Oeuvres 1915–1954*, exh. cat., Galerie Louise Leiris, Paris, 1985, p.23, no.13. In *Donation Louise et Michel Leiris: Collection Kahnweiler-Leiris*, exh. cat., Centre Georges Pompidou, Musée national d'art moderne 1984, the Centre Pompidou's terracotta cast of this work is identified as one of an edition of four, but the Tate's work is inscribed on the reverse 'no.8'.

7 Repr. in *Henri Laurens*, exh. cat., Deutsche Gesellschaft für Bildende Kunst, Berlin 1967, no.114.

Fernand Léger

1 Later renamed *Nudes in the Forest* (Kröller-Müller Museum, Otterlo).

2 Claude Laugier, 'Fernand Léger, 1881–1955', in *Donation Louise et Michel Leiris: Collection Kahnweiler-Leiris*, exh. cat., Musée National d'Art Moderne, Centre Georges Pompidou, Paris 1984, p.114.

3 Quoted in ibid, p.114.

4 Letter from Nadia Léger to Daniel-Henry Kahnweiler, 22 Dec. 1973, quoted in Pierre Assouline, *An Artful Life: A Biography of D.H. Kahnweiler, 1884–1979*, trans. Charles Ruas, New York 1990, p.322.

5 Quoted in Jean Leymarie, 'Léger's Drawings and Gouaches', Jean Cassou and Jean Leymarie, *Léger: Drawings and Gouaches*, trans. W.K. Haughan, London 1973, p.45.

6 Christopher Green, *Léger and the Avant-garde*, New Haven and London 1976, p.282.

7 Quoted in Leymarie, Cassou and Leymarie, London 1973, p.87.

André Masson

My thanks to Guite Masson for her help in determining the titles and dates of some of these works.

1 Quoted in Pierre Assouline, *An Artful Life: A Biography of D.H. Kahnweiler, 1884–1979*, trans. Charles Ruas, New York 1991, p.202.

2 Daniel-Henry Kahnweiler, with Francis Crémieux, *My Galleries and Painters*, London 1971, p.97.

3 *Donation Louise et Michel Leiris: Collection Kahnweiler-Leiris*, exh. cat., Centre Georges Pompidou, Musée national d'art moderne, Paris, Nov. 1984, p.135.

4 Guite Masson of the Comité André Masson is unaware of any surviving correspondence between Masson and Gustav Kahnweiler (conversation, Oct. 2003).

5 Rothenstein consulted the Trustees on this point of principle and responded that it was not the practice of the Tate Gallery to fall in with the exhibition schedules of commercial galleries (letter dated 31 March 1955). Writing from Ravello near Salerno on 7 May 1955, Kahnweiler replied that he perfectly understood, although he would be pleased if this painting – 'which I personally appreciate very much' – might be shown at a later date when appropriate.

6 Georges Limbour, 'Scenes of Everyday Life', trans. Douglas Cooper, in Michel Leiris and Georges Limbour, *André Masson and his Universe*, Geneva and Paris 1947, p.v.

7 Dawn Ades, *André Masson*, trans. Jacques Tranier, Paris 1994, p.15.

8 André Masson, 'Towards Boundlessness', in *André Masson: Recent Work and Earlier Paintings*, exh. cat., Curt Valentin Gallery, New York 1953, [p.4].

9 André Masson, 'Monet le Fondateur', in *Verve*, VII, no.27–8, Jan. 1953, p.68. With thanks to Guite Masson for providing me with this article.

10 Daniel-Henry Kahnweiler, 'André Masson', in *André Masson: Recent Work and Earlier Paintings*, [p.8].

11 Ibid,, [p.10].

12 Letter from M. Amiel, of Les Amis du Vieux Riez, dated 30 October 2003.

13 Quoted in *Donation Louise et Michel Leiris*, p.144 .

Henry Moore

1 The Museum of Modern Art, New York.

2 Postcard from Moore to Gustav and Elly Kahnweiler, Hotel Byron, Forte dei Marmi, 4 Sept. 1961 (Tate Archive TGA 9223.1.2).

3 Postcard from Moore to Gustav and Elly Kahnweiler, Forte dei Marmi, 23 August 1970 (Tate Archive TGA 9223.1.9).

4 Letter from Peter Jellinek to Tate, 4 May 1989.

5 Letter from Gustav Kahnweiler to Moore, Hotel Moresco, Ischia, 12 May 1963 (The Henry Moore Foundation, Much Hadham).

6 Letter from Moore to Gustav Kahnweiler, 25 Jan. 1956 (The Henry Moore Foundation, Much Hadham).

7 Moore, 1968, quoted in Alan Wilkinson (ed.), *Henry Moore: Writings and Conversations*, Aldershot 2002, p.239.

8 Letter from Moore to Gustav Kahnweiler, 9 Aug. 1956 (The Henry Moore Foundation, Much Hadham).

9 Letters from Sir Norman Reid to Gustav Kahnweiler, 7 May 1974 and from Kahnweiler to Reid 19 May 1974; Tate internal memorandum, 10 June 1974.

10 Quoted in *Henry Moore: Maquettes and Working Models*, exh. cat., The Nelson-Atkins Museum of Art, Kansas City 1987, p.6.

11 Moore, 1954, quoted in Wilkinson, 2002, p.280.

12 Ibid.

Pablo Picasso

1 Daniel-Henry Kahnweiler, with Francis Crémieux, *My Galleries and Painters*, trans. Helen Weaver, London 1971, p.38.

2 Ibid, p.38.

3 Ibid, p.39.

4 Ibid, p.42.

5 Fernande Olivier, *Loving Picasso: The Private Journal of Fernande Olivier*, trans. Christine Baker and Michael Raeburn, New York 2001, p.260.

6 Quoted in *Donation Louise et Michel Leiris: Collection Kahnweiler-Leiris*, exh. cat., Musée National d'Art Moderne, Centre Georges Pompidou, Paris 1984, p.169.

7 Quoted in ibid, p.169.

8 Letter from Picasso to Kahnweiler, Paris, 18 Dec. 1912, quoted in Kahnweiler 1971, p.154.

9 Kahnweiler 1971, pp.71, 104.

10 Pierre Assouline, *An Artful Life: A Biography of D.H. Kahnweiler, 1884–1979*, trans. Charles Ruas, New York 1991, p.336.

11 Ibid, p.339.

12 In Lionello Venturi, *Mostra di Pablo Picasso*, Rome 1953.

13 Brigitte Baer, *Picasso the Printmaker: Graphics from the Marina Picasso Collection*, Museum of Art, Dallas 1983, p.98.

14 Ibid.

15 Daniel-Henry Kahnweiler, 'Introduction: A Free Man', in Roland Penrose and John Golding (eds.), *Picasso 1881/1973*, London 1973, p.7.

16 *Picasso the Printmaker*, Dallas 1983, p.98.

17 Kahnweiler 1971, p.108.

18 Quoted in Jean Sutherland Boggs, 'The Last Thirty Years', in Penrose and Golding 1973, p.205.

19 Mourlot 1970, p.123.

20 Sutherland Boggs in *Picasso 1881/1973*, p.205.

21 See the many photographs of this studio in David Douglas Duncan, *Viva Picasso: A Centennial Celebration, 1881–1981*, New York 1980, especially frontispiece, pp.5, 30 and 55.

22 Michael FitzGerald, *Picasso: The Artist's Studio*, exh. cat., Wadsworth Atheneum Museum of Art, Hartford 2001, p.148.

23 Quoted by Sir Norman Reid in a letter to Tate, 13 December 2003.

24 Daniel-Henry Kahnweiler, 'Pour saluer Pablo Picasso', *Picasso: Peintures 1955–1956*, exh. cat., Galerie Louise Leiris, 1957, [p.6].

25 Daniel-Henry Kahnweiler, 'Introduction: A Free Man', in Penrose and Golding 1973, pp.8–9.

Exhibition Histories Note: histories are given for Kahnweiler works before their accession into Tate's collection.

Georges Braque

The Billiard Table 1945

1971 *Exposition René Char*, Musée d'Art Moderne de la Ville de Paris and Fondation Maeght, Saint-Paul de Vence, summer–autumn, no.558.

1973 Musée Despiau Wlerick, Mont de Marsan, July–Aug., no.1.

1980 *Georges Braque*, Fondation Maeght, Saint-Paul de Vence, July–Sept., no.112.

Georges Braque en Europe: Centenaire de la naissance de Georges Braque (1882–1963), Galerie des Beaux-Arts, Bordeaux, May–Sept,, Musée d'Art Moderne, Strasbourg, Sept.– Nov., no.67, repr. p.207.

1982–3 *Georges Braque: The Late Paintings 1940–1963*, Phillips Collection, Washington, D.C., Oct.–Dec. 1982, Fine Arts Museum of San Francisco, California Palace of the Legion of Honour, Jan.–Mar. 1983; Walker Art Center, Minneapolis, April–June; Museum of Fine Arts, Houston, July–Sept., no.15, repr. p.55 in colour, as *The Small Billiard Table*.

1984–5 *La Grande Parade: Hoogtepunten van de schilder skunstna 1940/Highlights in Paintings after 1940*, Stedelijk Museum, Amsterdam, Dec. 1984–April 1985, repr. p.63 in colour.

1986–7 *Georges Braque 1882–1963*, Museo Picasso, Barcelona, Nov. 1986–Jan. 1987, no.69, repr. p.215 in colour.

1988 Kunsthalle Munich, March–May, no.61

1988 *Georges Braque*, Solomon R. Guggenheim Museum, New York, June–Sept., no.69, repr. in colour opposite (n.p.) and p.17.

1990 *Braque: Still Lifes and Interiors*, Walker Art Gallery, Liverpool, Sept.–Oct.; Bristol Museum and Art Gallery,

Oct.–Dec., no.28, repr. p.53 in colour.

1997–8 *Braque: The Late Works*, Royal Academy of Arts, London, Jan.–April, no.12; Menil Collection, Houston, April–Aug., repr. p.57 in colour.

1998 Marugame Genichiro Inokuma Museum of Contemporary Art, Japan, June–July; The Bunkamura Museum of Art, Tokyo, Sept.–Oct.; Mie Prefectural Art Museum (Mie Kenritsu Bijutsukan), Japan, Nov.–Dec., repr. p.131.

1999 *Georges Braque: L'Espace*, Musée Malraux, Le Havre, March–June, not numbered, repr. p.81 in colour.

Juan Gris

Bottle of Rum and Newspaper 1913–14

1947 *The Cubist Spirit in its Time*, London Gallery, London, March, no.23, as *Nature morte avec bouteille*, 1913.

1955–6 *Juan Gris*, Kunstmuseum, Bern, Oct. 1955–Jan. 1956, no.14.

1958 *Juan Gris, 1887–1927*, Marlborough Fine Art Ltd, London, Feb.–March, no.5, as *La Bouteille*, 1913.

1965–6 *Juan Gris*, Museum am Ostwall, Dortmund, Oct.–Dec.; Wallraf-Richartz Museum, Cologne, Dec. 1965–Feb. 1966, no.19 (repr.) *Homage to Guillaume Apollinaire*, Institute of Contemporary Arts, London, Nov., no.274, as *La Bouteille*.

1974 *Juan Gris*, Orangerie des Tuileries, Paris, March–July, no.27 (repr.), as *La Bouteille de rhum / La Bouteille de rhum et le journal*, 1914.

1974 *Juan Gris*, Staatliche Kunsthalle, Baden-Baden, July–Sept., no.22, as *Bouteilles de rhum et journal* (repr.).

1983 *The Essential Cubism*, Tate Gallery, London, April–July, no.65, as *Bouteille de rhum et journal*.

1985 *Juan Gris (1887–1927)*, Salas Pablo Ruiz Picasso, Madrid, Sept.–Nov., no.23, repr. in colour, as *Bouteille de rhum et journal*.

Seated Harlequin 1920

1955–6 *Juan Gris*, Kunstmuseum, Bern, Oct. 1955–Jan. 1956, no.146, as *Pierrot*.

1965–6 *Juan Gris*, Museum am Ostwall, Dortmund, October–December, and Wallraf-Richartz Museum, Cologne, Dec. 1965–Feb. 1966, no.139, as *Pierrot*.

1974 *Juan Gris*, Orangerie des Tuileries, Paris, March–July, no.145, as *Pierrot*, repr.

1974 *Juan Gris*, Staatliche Kunsthalle, Baden-Baden, July–Sept., no.Z36, as *Pierrot*, repr.

Overlooking the Bay 1921

1936 *Juan Gris*, Mayor Gallery, London, Nov., no.5, as *La Baie*.

1955–6 *Juan Gris*, Kunstmuseum, Bern, Oct. 1955–Jan. 1956, no.89.

1956 28th Venice Biennale, May–Nov., room 51, no.19.

1958 *Juan Gris*, The Museum of Modern Art, New York, April–June; Minneapolis Art Institute, Minneapolis, June–July; Museum of Modern Art, San Francisco, Aug.–Sept.; County Museum, Los Angeles, Sept.–Oct., repr. p.105.

1965–6 *Juan Gris*, Museum am Ostwall, Dortmund, Oct.–Dec.; Wallraf-Richartz Museum, Cologne, Dec. 1965–Feb. 1966, no.68, repr.

1974 *Juan Gris*, Orangerie des Tuileries, Paris, March–July, no.87, repr.

1974 *Juan Gris*, Staatliche Kunsthalle, Baden-Baden, July–Sept., no.71, repr.

Coffee Mill 1924

1958 *Juan Gris: Exhibition in Honour of Daniel-H. Kahnweiler*, Marlborough Fine Art Ltd, London,

Feb.–March, no.17, as *La Cafétière*.

1965–6 *Juan Gris*, Museum am Ostwall, Dortmund, Oct.–Dec.; Wallraf-Richartz Museum, Cologne, Dec. 1965–Feb. 1966, no.149.

Bowl of Fruit 1924

1936 *Juan Gris*, Mayor Gallery, London, Nov., no.10, as *Nature morte au compotier*.

1955–6 *Juan Gris*, Kunstmuseum, Bern, Oct. 1955–Jan. 1956, no.164.

1965–6 *Juan Gris*, Museum am Ostwall, Dortmund, Oct.–Dec.; Wallraf-Richartz Museum, Cologne, Dec. 1965–Feb. 1966, no.153.

Pipe and Domino 1924

1936 *Juan Gris*, Mayor Gallery, London, Nov., no.11, as *Nature morte: Pipe et Domino*.

1955–6 *Juan Gris*, Kunstmuseum, Bern, Oct. 1955–Jan. 1956, no.168.

1958 *Juan Gris, 1887–1927*, Marlborough Fine Art Ltd, London, Feb.–March, no.27 (wrong measurements).

1965–6 *Juan Gris*, Museum am Ostwall, Dortmund, Oct.–Dec.; Wallraf-Richartz Museum, Cologne, Dec. 1965–Feb. 1966, no.150.

Still Life with Guitar 1924

1936 *Juan Gris*, Mayor Gallery, London, Nov., no.7, as *Nature morte à la guitare*.

1955–6 *Juan Gris*, Kunstmuseum, Bern, Oct. 1955–Jan. 1956, no.165, as *Guitare et carafe*.

1958 *Juan Gris, 1887–1927*, Marlborough Fine Art Ltd, London, Feb.–March, no.29, as *Guitare*, repr.

1965–6 *Juan Gris*, Museum am Ostwall, Dortmund, Oct.–Dec.; Wallraf-Richartz Museum, Cologne, Dec. 1965–Feb. 1966, no.151, as *Guitare*.

1974 *Juan Gris*, Orangerie des Tuileries, Paris, March–July, no.159, as *Nature morte*, repr.

1974 *Juan Gris*, Staatliche Kunsthalle, Baden-Baden, July–Sept., no.Z48, as *Nature morte*, repr.

1985 *Juan Gris (1887–1927)*, Salas Pablo Ruiz Picasso, Madrid, Sept.–Nov., no.179, as *Guitare, compotier et carafe*, repr. in colour.

Pierrot with Book 1924

1936 *Juan Gris*, Mayor Gallery, London, Nov., no.23, as *Le Pierrot*.

1955–6 *Juan Gris*, Kunstmuseum, Bern, Oct. 1955–Jan. 1956, no.101.

1956 28th Venice Biennale, May–Nov., room 51, no.22.

1965–6 *Juan Gris*, Museum am Ostwall, Dortmund, Oct.–Dec.; Wallraf-Richartz Museum, Cologne, Dec. 1965–Feb. 1966, no.79.

1974 *Juan Gris*, Orangerie des Tuileries, Paris, March–July, no.99, repr. in black and white and p.61 in colour.

1985 *Juan Gris (1887–1927)*, Salas Pablo Ruiz Picasso, Madrid, Sept.–Nov., no.88, repr. in colour.

Henri Laurens

Head of a Young Girl 1920

1958 *Henri Laurens: Sculptures en Pierre 1919–1943*, exh. cat., Galerie Louise Leiris, Paris, Oct. 1958, no.12, repr.

Pablo Picasso

The Studio 1955

1957 *Picasso: Peintures 1955–1956*, exh. cat. Galerie Louise Leiris, Paris, March–April 1957, no.11, repr. in colour.

Bullfight Scene 1960

1960 *Picasso: Dessins 1959–1960*, exh. cat., Galerie Louise Leiris, Paris, Nov.–Dec. 1960, no.32, repr.

List of Works

Works accessioned into the Tate Gallery Archive

Renato Guttuso 1912–1987

Gustav Kahnweiler 1966
Pencil on paper
80 × 59
Inscribed 'Caro Gustav, contentati, intanto | di questo inizio. | Con tutta la mia amicizia | Renato | Guttuso | Roma 1966' b.l. in pencil
TGA 9223.2.1

Elie Lascaux 1888–1969

[Birthday card for Gustav Kahnweiler] 1950
Pen and ink and crayon on paper
31.4 × 22.8
Inscribed 'A mon cher Gustave | pour son anniversaire | Elie | Boulogne s/Seine | 21 Sbre 1950' b.r. in black ink
TGA 9223.2.2

[Wedding anniversary card for Gustav and Elly Kahnweiler] 1950
Pen and ink, watercolour and silver paint on paper
30 × 23
Inscribed 'A Elly et à Gustave | pour leur 25 ans de mariage | Elie Lascaux | 50' b.r. in black ink
TGA 9223.2.3

[View of Gustav and Elly Kahnweiler's house in Cambridge] 1950
Pencil and crayon on paper
23.5 × 31.5
Inscribed 'A Elly et à Gustave | en souvenir de nos bons | moments à Cambridge | juin 1950 | Elie Lascaux' b.r. in black ink
TGA 9223.2.4

André Masson 1896–1987

Daniel-Henry Kahnweiler 1946
Lithograph on paper
45.3 × 32
Inscribed 'Epreuve d'artiste' b.l., 'André Masson' b.r. and 'A Elly et Gustave | avec l'affection de | Heini | Noël 1946' b.r. in pencil
TGA 9223.2.5

José de Togores 1893–1970

Gustav Kahnweiler 1920s
Pencil on paper
35.3 × 24.5
Inscribed 'A Gustave Kahnweiler | sympathiquement | Togores' b.l. in pencil
TGA 9223.2.6

Works Sold

André Beaudin 1895–1979

Abstract 1956
Abstrait
Ink on paper
49 × 28
Sold to Galerie Louise Leiris, Paris

Trees 1959
Les Arbres
Oil on canvas
46 × 38
Sold to Galerie Louise Leiris, Paris

Francisco Borès 1898–1972

The Dead Zebra 1936
Le Zèbre mort
Gouache on paper
33 × 47
Sotheby's London, 14 March 1995, lot 296

Woman Sewing 1936
Femme cousant
Gouache on paper
32 × 40
Sotheby's London, 14 March 1995, lot 294

Fabrizio Clerici 1913–1993

Untitled n.d.
Etching on paper
50 × 34.8
Inscribed 'a Elly e Gustav | con | l'amicizia | di | Fabrizio' b.c.
Sotheby's London, 1 December 1994, lot 369

John Farnham born 1942

Bird 1976
Bronze
Height 91
Numbered 3/7
Sotheby's London, 14 March 1995, lot 67

Françoise Gilot born 1921

Spanish Oil Container 1951
L'Huilier espagnol
Crayon, charcoal and pencil on paper
50.4 × 65.3
Sotheby's London, 14 March 1995, lot 282

Juan Gris 1887–1927

Place Ravignan 1915
Pencil on paper
35.5 × 27
Sold to Galerie Louise Leiris, Paris

Bottle 1922
Bouteille
Oil on board
26.3 × 16
Sold to Galerie Louise Leiris, Paris

Houses 1924
Les Maisons
Gouache on paper
15.5 × 19.7
Sold to Galerie Louise Leiris, Paris

Renato Guttuso 1912–1987

Cain and Abel 1955
Caino e Abele
Oil on panel
18 × 24
Inscribed 'A Ely con amicizia Roma 1 maggio 1956' on verso
Sotheby's London, 14 March 1995, lot 251

[African Village] c.1960
Lithograph on paper
62 × 44.5
Inscribed 'a Ely | ricordo di | Renato | Roma 2-ott 60' bottom right
Sotheby's London, 1 December 1994, lot 223

[Garlic] c.1960
Etching on paper
49.5 × 69.8
Inscribed 'per Ely e Gustav, il loro | Renato' bottom right
Sotheby's London, 1 December 1994, lot 223

[Large Basket of Chestnuts] c.1960
Screenprint on paper
78 × 88
Inscribed 'per Ely, Renato' bottom right
Sotheby's London, 1 December 1994, lot 223

[Yellow Flowers] c.1960
Lithograph on paper
40 × 53
Inscribed 'per Ely | con affetto | Renato' bottom right
Sotheby's London, 1 December 1994, lot 223

Philippe-Sebastien Hadengue b. 1932

Warriors 1969
Les Guerriers
Felt-tip pen on paper
39 × 53.5
Sotheby's London, 25 October 1995, lot 113/ii

Eugène-Nestor de Kermadec 1899–1976

Lips 1929
Lèvres
Oil on canvas
33.5 × 23
Sotheby's London, 14 March 1995, lot 290

Marine Wildlife 1958
Faune marine
Oil on canvas
45 × 61
Sotheby's London, 14 March 1995, lot 287

Another Attempt to Notify the Appellants (No.2) 1957
Autre tentative ou signifier les appelants (No.2)
Oil on canvas
33 × 46
Sotheby's London, 14 March 1995, lot 292

Nude n.d.
Nu
Crayon on paper
33 × 26
Sold to Galerie Louise Leiris, Paris

Nude n.d.
Nu
Crayon on paper
33.5 × 26
Sold to Galerie Louise Leiris, Paris

Nude n.d.
Nu
Coloured crayon on paper
34.5 × 26.5
Sold to Galerie Louise Leiris, Paris

Nude n.d.
Nu
Pencil and crayon on paper
26.2 × 34.5
Sold to Galerie Louise Leiris, Paris

Paul Klee 1879–1940

Animals in Moonlight 1919
Tiere im Mondschein
Pencil on cloth-textured paper on the artist's mount
30.6 × 23.8
Sotheby's London, 30 November 1994, lot 169

Friend (A Memorial Page) 1923
Ami (Ein Gedenkblatt)
Oil transfer, pen and ink and *Spritztechnik* on paper mounted on the artist's mount with watercolour
35.3 × 22.7
Sotheby's London, 30 November 1994, lot 172

Elephant Couple 1926
Elefantenpaar
Pen and ink and *Spritztechnik* on paper on the artist's mount
26.1 × 30
Sotheby's London, 30 November 1994, lot 170

Moissej Kogan 1879–1930

[Title not known] n.d.
Etching
15.5 × 14.5
Sotheby's London, 1 December 1994, lot 369

Elie Lascaux 1888–1969

In the Forest of Chaville 1931
Dans la forêt de Chaville
Watercolour, gouache, crayon and pencil on paper
48.5 × 66.4
Sotheby's London, 14 March 1995, lot 279

The Bell Tower of St. Severin
1959
Clocher St. Severin
Oil on canvas
40 × 27
Sotheby's London, 25
October 1995, lot 113/iii

The City n.d.
La Ville
Pencil on paper
31.8 × 23.9
Sotheby's London,
14 March 1995, lot 306/i

**Houses in front of the
Cathedral of Limoges** n.d.
*Les Maisons devant la
cathédrale de Limoges*
Pencil and coloured crayon
on paper
61 × 49.5
Sotheby's London,
14 March 1995, lot 306/ii

Old Houses n.d.
Vieilles Maisons
Oil on canvas
73 × 60
Sotheby's London,
14 March 1995, lot 305

Winter Street n.d.
Rue en hiver
Oil on canvas
65.2 × 54.2
Sotheby's London,
14 March 1995, lot 304

Marie Laurencin 1885–1956

Couple Dancing n.d.
Couple dansant
Pencil on paper
19.8 × 11.7
Sotheby's London, 25
October 1995, lot 152/v

Head of a Dog n.d.
Tête de chien
Ink on paper
7.7 × 7.7
Sotheby's London,
25 October 1995, lot 152/ii

Head of a Young Girl n.d.
Tête de jeune fille
Pencil on paper
18.7 × 14.8
Sotheby's London,
25 October 1995, lot 152/i

Three Children n.d.
Trois enfants
Pencil on paper
13.6 × 10.9
Sotheby's London,
25 October 1995, lot 152/iv

View from the Balcony n.d.
Vue du balcon
Pencil on paper
18.5 × 14.8
Sotheby's London,
25 October 1995, lot 152/vii

Theatre Scene n.d.
Scène de théâtre
Pencil on paper
15.8 × 12.4
Sotheby's London,
25 October 1995, lot 152/iii

Woman on a Swing n.d.
Femme à la balançoire
Pencil on paper
19.6 × 9.7
Sotheby's London,
25 October 1995, lot 152/vi

Henri Laurens 1885–1954

Head 1917
Tête
Collage on paper
27.8 × 24.7
Sold to Galerie Louise
Leiris, Paris

Figure c.1918
Figure
Etching on paper
33 × 24.7
Sold to Galerie Louise
Leiris, Paris

Water Sprites 1932
Ondines
Bronze
18.5 × 38.5 × 11
Sold to Galerie Louise
Leiris, Paris

[No title] 1951
Lithograph on paper
50 × 64.5
Sold to Galerie Louise
Leiris, Paris

Fernand Léger 1881–1955

Still Life with Flower Pot 1951
Nature morte au pot de fleurs
Watercolour, Indian ink and
pencil on paper
29.6 × 21.7
Sotheby's London, 30
November 1994, lot 178

Logs 1952
Les Bûches
Watercolour and brush
and Indian ink on paper
22.1 × 15.6
Inscribed indistinctly to
Elly Kahnweiler
Sotheby's London,
30 November 1994, lot 177

Manolo (Manuel Martinez
Hugué) 1872–1945

Catalan Girl 1914
Jeune Catalane
Charcoal on paper
28.6 × 22.5
Sotheby's London,
14 March 1995, lot 199

Leda and the Swan 1930
Leda et le cygne
Bronze
Height 7.3
Sotheby's London,
14 March 1995, lot 177/i

Picador n.d.
Le Picador
Pen and ink and wash
on paper
25 × 21.3
Sotheby's London,
14 March 1995, lot 177/ii

André Masson 1896–1987

Three Cards c.1923–4
Trois cartes
Crayon on paper
24 × 35
Sold to Galerie Louise
Leiris, Paris

Still Life with Glasses c.1924
Nature morte aux verres
Oil on canvas
35.5 × 28
Sotheby's London,
30 November 1994, lot 176

Dominoes mid-1920s
Dominos
Oil on canvas
23 × 27
Sotheby's London,
30 November 1994, lot 175

Abstract Portrait c.1924–5
Portrait abstrait
Crayon on paper
47 × 38
Sold to Galerie Louise
Leiris, Paris

Untitled 1925
Indian ink on paper
32 × 24.2
Sold to Galerie Louise
Leiris, Paris

Head c.1926
Tête
Crayon on paper
51.9 × 38.8
Sotheby's London,
30 November 1994, lot 180

Woman Dreaming 1927
Femme rêvant
Crayon on paper
63.5 × 48
Sotheby's London,
14 March 1995, lot 302

Fish Combat 1928
Combat de poissons
Pen and ink on paper
30.1 × 24
Sotheby's London,
14 March 1995, lot 293

Water Sprite 1934
Ondine
Etching on paper
51 × 38.2
Numbered 7/10
Sotheby's London,
1 December 1994, lot 246

Frogs c.1948
Les Grenouilles
Lithograph on paper
65.5 × 50
Sotheby's London,
1 December 1994, lot 248

[Landscape] c.1948
Lithograph on paper
57 × 38
Sotheby's London,
1 December 1994, lot 248

[Venice] c.1948
Lithograph on paper
44 × 53
Sotheby's London,
1 December 1994, lot 248

[Abstract Composition] c.1950
Lithograph on paper
38 × 53
Inscribed 'A Gustave et
Elly pour leur anniversaire
(vingt-cinq ans de mariage)'
b.c.
Sotheby's London,
1 December 1994, lot 245

[Landscape] c.1950
Lithograph on paper
45 × 58
Sotheby's London,
1 December 1994, lot 245

[Man's Head] c.1950
Lithograph on paper
57 × 38
Inscribed 'A Gustave et
Elly pour leur anniversaire
(vingt-cinq ans de mariage)'
b.l.
Sotheby's London,
1 December 1994, lot 245

[Nude Study] c.1950
Lithograph on paper
33 × 25.5
Inscribed 'A Gustave et
Elly pour leur anniversaire
(vingt-cinq ans de mariage)'
b.l.
Sotheby's London,
1 December 1994, lot 245

Cocks 1954
Les Coques
Brush and ink on paper
64 × 49
Sotheby's London,
25 October 1995, lot 134

Before the Sea 1955
Devant la mer
Gouache and sand on canvas
22.1 × 30
Sotheby's London,
30 November 1994, lot 173

Birth of a Muse after Ingres
c.1970
*Naissance d'une muse d'après
Ingres*
Crayon and pen and
Indian ink on paper
49.3 × 63.8
Sotheby's London,
30 November 1994, lot 179

Joan Miró 1893–1983

**Person Charmed by
a Dancer** 1937
*Personnage charmé par
une danseuse*
Oil on acoustic tile
30.2 × 15.2
Sotheby's London,
30 November 1994, lot 174

Composition c.1945
Watercolour, gouache and
brush and ink on paper
18.1 × 13.7
Sotheby's London,
30 November 1994, lot 181

Henry Moore 1898–1986

**Six Reclining Figures with Buff
Background** 1963
Lithograph on paper
60.8 × 73.3
Inscribed 'For Gustav
Kahnweiler' b.l.
Sotheby's London,
1 December 1994, lot 302

**Two Reclining Figures with
River Background** 1963
Lithograph on paper
49.8 × 81.7
Inscribed 'For | Gustav
Kahnweiler' b.l.
Sotheby's London,
1 December 1994, lot 302

Pablo Picasso 1881–1973

Pedestal Table c.1920
Le Gueridon
Gouache on paper
26.6 × 20.5
Sotheby's London,
30 November 1994, lot 171

**Fauns and Female
Centaur** 1947
Les Faunes et la centauresse
Lithograph on paper
49.6 × 65.5
Sotheby's London,
1 December 1994, lot 335

Page Boys at Play 1951
Jeux de pages
Lithograph on paper
32 × 42.5
Sold to Galerie Louise
Leiris, Paris

Faun's Head 1956
Tête de faune
Ceramic tile
15.2 × 15.2
Sold to Galerie Louise
Leiris, Paris

Diurnals 1962
Diurnes
Linocut on paper
54.8 × 43.2
Sotheby's London,
1 December 1994, lot 342

Suzanne Roger 1898–1986

Woman 1926
Femme
Pencil on paper
32.3 × 25
Sotheby's London,
14 March 1995, lot 277/iii

Head of a Woman 1933
Tête de femme
Watercolour on paper
23.8 × 31.6
Sotheby's London,
14 March 1995, lot 277/ii

Women 1933
Femmes
Gouache on paper
63.8 × 47.7
Sotheby's London,
14 March 1995, lot 277/i

Yves Rouvre 1910–1996

Quarry 1953
La Carrière
Oil on canvas
38 × 58
Sotheby's London,
25 October 1995, lot 113/iv

Gaston Louis Roux 1904–1987

Composition 1928
Composition
Watercolour, gouache and
pencil on paper
23.8 × 31.2
Sotheby's London,
14 March 1995, lot 281/i

Composition 1928
Composition
Gouache, watercolour,
charcoal and pencil on paper
(verso: pencil on paper)
23.5 × 31
Sotheby's London,
14 March 1995, lot 281/ii

José de Togores 1893–1970

Farrier 1927
Le Maréchal-ferrant
Oil on canvas
14.2 × 21.9
Sotheby's London, 14 March
1995, lot 267A/i

Xavier Vilató b. 1921

Nude on the Beach 1955
Nu sur la plage
Watercolour and
ball-point pen on paper
29.3 × 20.2
Inscribed 'Pour Elly' t.r.
Sotheby's London,
14 March 1995, lot 291

Maurice de Vlaminck
1876–1958

Street in Hérouville 1921
Rue à Hérouville
Lithograph on paper
38.5 × 47
Sotheby's London,
1 December 1994, lot 412

Verville 1921
Lithograph on paper
38.5 × 47
Sotheby's London,
1 December 1994, lot 412

Works of Uncertain
Attribution

Attributed to **Elie Lascaux**
1888–1969

Vauvenargues 1959
Pencil and ball-point pen
on paper
12 × 14.5
Inscribed 'Pour Holy'
Sotheby's London,
14 March 1995, lot 267A/ii

**Twentieth-Century
French School**

Head n.d.
Tête
Stone
Height 11.8
Sotheby's London, 25
October 1995, lot 113/i

Unknown artists

[Title not known] n.d.
Wood engraving on paper
9.3 × 4.4
Sotheby's London,
1 December 1994, lot 369

[Title not known] n.d.
Etching
15.1 × 11.5
Sotheby's London,
1 December 1994, lot 369

[Title not known] n.d.
Etching
17.2 × 12
Sotheby's London,
1 December 1994, lot 369

[Title not known] n.d.
Etching
12.5 × 17.2
Sotheby's London,
1 December 1994, lot 369

[Title not known] n.d.
Etching
17.2 × 12.5
Sotheby's London,
1 December 1994, lot 369

[Title not known] n.d.
Etching
11.5 × 8.5
Sotheby's London,
1 December 1994, lot 369

Credits

Copyright

Photo credits

Index Note: numbers in bold indicate main catalogue entries.